fishstonewater | *holy wells of ireland*

Written by Anna Rackard | Photography by Liam O'Callaghan | Introduction by Angela Bourke

fishstonewater

holy wells of Ireland

First published in 2001 by ATRIUM, Cork, Ireland

Atrium is an imprint of Attic Press Ltd
Crawford Business Park, Crosses Green, Cork

Photographs by Liam O'Callaghan except pages 29, 37, 83 by Anna Rackard

ISBN 0 9535353 1 2

Designed by David Joyce

Printed in China. Produced by Phoenix Offset.

Very special thanks to Críostóir Mac Cártaigh from the Department of Irish Folklore,
UCD, Brendan Barrington, Helen Moss and Jonathan Williams for all their help and
encouragement. Thanks also to Patricia O'Hare, Sr de Lourdes Fahy, Jude Flynn,
Ray Astbury, Maurice Craig, Andrew Carpenter and Finoula Williams. Finally,
thanks to all the people we encountered along the way who gave willingly of
their time and local knowledge, and made our journey all the more interesting
and rewarding.

Dedicated to Bobby, Betty, Ethel and Donal

Author's note:
I have endeavoured to use the wells' most commonly used names. Some wells are
known by both an Irish and an English name, and in these cases both are cited.
Occasionally the word 'tober' is used (e.g. Tobermurry); it is an anglicised form of
the Irish *tobar* meaning well.

Contents

Introduction

A visit to a holy well, especially if we are strangers in the area, may leave us with more questions than answers. Who says the well is holy? Why? If there is a fence, or a gate, or a covering over the well, who built them? Who has left these tokens, and how long ago? Are we trespassing? What is expected of us? Is this religion, or magic, or folk-medicine? Is it a Catholic devotion, or something older? Is it unique to Ireland? If this is an ancient site of worship, why are there ashtrays and broken china, canteen chairs and modern statues? Does the water have special properties? Is anyone in charge? If there are stories about the well, where are they written? Who is this saint whose name is attached to it? Should we have come on a special day? Or if this is the 'pattern' day, when dozens or hundreds of people gather at the well to pray, where have they come from, and what do they believe?

Estimates put the number of holy wells in Ireland at around 3,000. Anna Rackard and Liam O'Callaghan have visited some two hundred over the last five years, photographing them and talking to people about them for this disturbingly beautiful photographic essay. Some wells are hardly visited now, or have been filled in or made inaccessible by building; others attract many hundreds to their annual pattern or patron days, when the local saint is honoured. Pilgrims make the clockwise circuit or 'rounds' (*turas* in Irish) as their parents and grandparents did before them, visiting a number of stations, or recognised points around the site, and praying at each one, perhaps handling or kissing certain stones or other objects which lie there, drinking the water, and leaving something behind. The prayers to be said are usually prescribed: a certain number of Hail Marys, Our Fathers and Glorias at each station. When the praying is done, the social part of the pattern can begin, and neighbours meet, to talk. Some wells are famous for many miles around as places where sore eyes may be cured, or headaches, or warts, or even mental illness and infertility. 'Curing stones' may be borrowed from them for people unable to travel, and water may be carried away in bottles, but most of the virtue of the holy well is found by visiting it. Passing a holy well while going about other business, people stop to say a prayer and drink some water, and almost everyone will leave a token in exchange, as so many of these photographs show, though it may be no more than a button, a seashell, or a small stone.

The stories told at holy wells, retold in many places in this book, are brief, but memorable and arresting. The well appeared when a saint shed tears on leaving this beautiful place, or water burst forth when a holy man struck the rock with his crozier. There was a forge near the well, where a holy woman went every day to collect live embers for her fire; she used to carry them home in her apron until the smith praised her legs and she looked down, whereupon the fire burned

through the apron. The well used to be some distance from where it is now, until a woman profaned it by washing clothes in it, and it moved. Its power can work for evil as well as good, and a *turas* may be made against the sun, or certain stones turned anti-clockwise, to place a curse. Often it is said that mysterious trout or eels live in the well. The fish, of course, is a symbol of Christianity, but it is worth remembering the Well of Segais in early Irish literature, supposed to be the source of the Boyne, where five salmon lived, feeding on the hazelnuts that fell from nine trees that grew around it. Eating the salmon gave the gift of poetic vision, while now the water of a holy well cures sore eyes, and those who see the fish are blessed.

Ancient trees overhang many holy wells, and just as the water will not boil, their branches will not burn. Often the tree—most likely a whitethorn, a holly or an ash—will be decked with rags. In some places the rags used to be red, perhaps torn from flannel petticoats. Pilgrims would use a piece of cloth to wash the afflicted body part, then tie the cloth to the tree, leaving the illness behind. Nowadays, rags are any colour, and may include plastic bags and crisp packets, and among the tokens left behind are written pleas: brief notes about the troubles people suffer. Pilgrims leave notes like these at Buddhist temples too, and travellers write them in visitors' books in the chapels of international airports.

In the nineteenth century, while colonial officials mapped the territories of the new world, and wars and nation-building altered the landscape of the old, antiquaries roamed the countrysides and islands of Europe, often in organised groups, sketching and describing field monuments of every kind and noting the details of traditional celebrations. Their work on stone circles, burial sites, ancient churches and holy wells furnished maps of the past—an influential sense of how our ancestors used to live and think—and applied the authority of science to things that had formerly been private or local. Their writings passed judgment, approving of some practices and condemning others. Tourists followed, travelling from cities and towns by steamship, train and charabanc to view antiquities, many of them in places to which pilgrims had formerly walked in search of cures for the body and blessings for the soul.

Nineteenth-century commentators noted that many wells traditionally venerated and resorted to for cures belonged to ancient sites. Some described the holy wells found all over Catholic Europe and beyond as monuments to piety, evidence of the tenacity of faith, even in the face of persecution; others, however, deplored them as symbols of degradation and superstition. Patterns attracted huge crowds, and included games, contests and other celebrations, some of them distinctly uninhibited. In 1836, Philip Dixon Hardy, member of the Royal Irish Academy and editor of the *Dublin Penny Journal*, published *The Holy Wells of Ireland*, which he advertised as 'a

brief though comprehensive description of some of the most noted of the "Holy Wells" of Ireland, which are still annually resorted to by thousands of the peasantry, as places of pilgrimage, penance, and purgatory'. Bleeding feet still characterise pilgrimages to St Patrick's Purgatory on Station Island in Lough Derg, County Donegal, and the ascent of Croagh Patrick, County Mayo, but such sights were widespread before the Famine of 1845–9. Pilgrims to holy wells would subject themselves to physical ordeals of the kind undergone in many cultures by those seeking mystical experience: walking great distances, fasting all day and making the prescribed 'rounds' over sharp rocks, barefoot or even on bare knees. Penitential practices like these had been common in mediaeval Europe, but they shocked nineteenth-century Protestants. Hardy's book includes an interview conducted at Struell wells, near Downpatrick, County Down, with a young man said to have walked there barefoot from County Galway in response to a dream or vision. 'Will you go home as soon as you have done all the stations?', his questioner asked. 'I will not be able, my feet are so sore,' was the reply. Hardy's informant continues: 'He then showed his feet; they were much bruised, and when he pulled up his drawers, his knees were nearly in a state of complete ulceration.'

Complete with engravings, Hardy's book was a meticulously documented attack on practices which the author condemned as 'prolific sources of much of the IRRELIGION, IMMORALITY, and VICE which at present prevail to such an awful extent through so many portions of our highly favoured land'. The waters of Struell wells were said to cure many ailments, and Hardy records that the midsummer pilgrims would tear off all their clothes and 'before the assembled multitudes . . . go forward in a state of absolute nudity, plunge in, and bathe promiscuously'. Even more shocking were the ways they consoled themselves afterwards:

In these tents, and in the adjoining fields, under the canopy of a pure sky, they spend the whole night, quaffing the soul-inspiring beverage, and indulging in various gratifications to which the time and place are favourable; for it is understood, that while the jubilee continues, and as long as the happy multitudes remain on the sacred ground, they cannot contract new guilt!

'I do hope', he wrote, 'that after an impartial investigation, the voice of an enlightened public will be raised against the longer continuance of practices as degrading and immoral as any of those which are attended to by the most unenlightened heathen nations . . .'

Hardy's arguments were echoed by others, and after the Famine, heeded by many, including Catholic clergy. The

rising Catholic middle class prayed now in fine new 'chapels', rather than at holy wells or mass-rocks, and while the church sanctioned traditional practices at some sites, it did so strictly on its own terms. Clergy discouraged drinking and merrymaking, and the leaving of rags, crutches and other votive offerings, but they might erect statues, celebrate masses, and welcome offerings of money at certain wells. Local populations intensified their attention to some sites, bringing their devotions into line with Victorian sensibility; but other holy wells were relegated to secrecy and the quiet attentions of an elderly and dwindling few. In remote places all over Europe, meanwhile, social and political upheaval led to the reporting of new apparitions, like those of the Virgin Mary in Lourdes in the French Pyrenees in 1858, in Marpingen in northern Germany in 1876, or in Knock, County Mayo, in 1879. Lesser phenomena were reported elsewhere, many of them, like Lourdes, centred on springs of water, and new places joined those already thought of as holy.

All human populations regard certain places as sacred: as having qualities that make them in some way the centre of the universe. Mecca is one such place; Bethlehem is another, but so, for some people, are Manchester United's Old Trafford, or Windmill Lane Studios. Sacred places may have physical characteristics that mark them off as special (think of Mont Saint Michel in northern France, and Sceilg Mhichíl off County Kerry), but it is enough that they are different from their surroundings, and are defined as such by stories. They are the places where remarkable people are believed to have done or experienced remarkable things, and where the faithful hope to share in that transcendence. Perhaps this is one reason so many pilgrims hope for cures, for sacred places hold out the possibility of leaving behind the limitations of the body.

In these cynical times the symbolic power of a freshwater spring can sell millions of poundsworth of bottled water every year. Ireland is a damp and often soggy place, but even in this green, misty island, water can be scarce in summer. Some holy wells are simply hollows where rainwater collects, but a well that does not dry up is the first requirement for a human settlement. A spring well promises purity, cleansing, and the slaking of thirst. Water that issues from rock speaks both of permanence and of new possibility: it is a perfect image of grace. Many places are called Lady's Well (or *Tobar Mhuire*), John's Well, or St Anne's Well, but the majority of holy wells in Ireland are dedicated to native saints, the robust, miracle-working, straight-talking holy men and women of early mediaeval Ireland. Unlike the post-Famine Catholic churches, dedicated to canonised saints or to the Immaculate Conception, Holy Name or Precious Blood, they bear names more often found attached to Protestant parishes established before the Reformation. There are hundreds of Patrickswells and

Bridewells, dozens of wells of St Colmcille and St Ciarán, while many others bear the names of saints all but unknown outside their areas: Moling in counties Carlow and Kilkenny; Caoidhe in Kilkee, County Clare, Mogue in counties Cavan and Leitrim (and in Ferns, County Wexford).

The holy wells of Ireland map time as well as space. Like the traditional recipes of seasonal cooking, they do not belong to every day, but to the special intervals when they are visited, and stories about them are remembered. The pattern day that honours a local saint brings people to walk paths and meet neighbours they may not have visited for months, or for a whole year, and to sniff the air and take in a view that is both like and unlike last year's. Today's St Patrick's Festival in Dublin is a new expression of the pattern: an assertion of local identity and a performance of place and time.

Some of the saints have clearly succeeded pre-Christian deities in the task of presiding over wells and other sacred sites. Máire MacNeill's encyclopaedic and poetic study *The Festival of Lughnasa* showed how visits to sacred places, including mountain tops and holy wells, marked the beginning of harvest in late July and early August, and allowed Patrick and other saints to inherit the places and many of the functions of the Celtic god Lugh. Other wells, like Struell, and *Tobar na mBan Naomh*, the Well of the Holy Women, in County Donegal, are visited on St John's Eve, 23 June—a Christian

enactment of the festival of midsummer. One holy well site at Randalstown, County Meath, dedicated to St Anne and excavated by E.P. Kelly of the National Museum of Ireland, showed evidence of continuous visitation, with offerings left behind over a period of some two thousand years. Perhaps the first Irish Christians built their sanctuaries on lands that were already holy, but in any case, the names they left behind on holy wells are among the most accurate markers of their activities.

Places of pilgrimage have always been what cultural critics call contested sites—places whose ownership and meaning can shift—for they are at once central and peripheral, often on boundaries and therefore capable of accommodating ambiguity, paradox and change. Holy wells which have apparently been abandoned may be rediscovered when new spiritual needs arise, so some are now centres of devotion for those who find mainstream religious practice corrupt and hope for a return to conservative authority, while others are the focus of New Age practices or celebrations of the Mother Goddess.

Most Irish holy wells are in beautiful places, and many have spectacular views, but this is not the Ireland of designer heritage, of *Entente florale* or the Tidy Towns Competition. Some wells are enclosed in chapels or presided over by statues that have stood for hundreds of years, but most are without carparks, lawns, hanging flower-baskets, restored stonework,

modern gates on oiled hinges, cafés or public toilets. To find
most holy wells in Ireland, you need a local guide, or you need
to remember. Some are below high-tide mark on beaches:
miraculous sources of spring water from underneath the salt;
others are overgrown, or on land that is wet and boggy
anyway. Only occasionally are they convenient to the public
road, or given official signposts; to the eye accustomed to styled
images, many are distinctly untidy. Bits of crockery lie around
their edges, alongside coins, shells and rusting medals; scraps of
rag flutter on branches overhead. Statues stand crowded
together without regard for scale or style of execution;
crucifixes are festooned with scapulars and rosary beads, many
of them broken. Some holy wells look like shrines to recycling,
where discarded fire-grates, bedsteads and even parts of
washing machines frame the tokens of devotion. This most
modest sort of holy well is not a dump, however: as the images
and texts in this book make clear, it is just the opposite, for the
rags, damaged statues and rusting metal are consigned not to
oblivion, but to memory.

Angela Bourke
Dublin
24 May 2001

References:

Philip Dixon Hardy, *The Holy Wells of Ireland*
(Dublin: Hardy & Walker, 1836) (available online at
http://website.lineone.net/~geoff.burton/index.html)

Patrick Logan, *The Holy Wells of Ireland*
(Gerrards Cross: Colin Smythe, 1980)

Máire MacNeill, *The Festival of Lughnasa: A Study of
the Survival of the Celtic Festival of the Beginning of
Harvest* (Dublin: Comhairle Bhéaloideas Éireann,
1982 [1962])

Lawrence J. Taylor, *Occasions of Faith:
An Anthropology of Irish Catholics* (Dublin: Lilliput
Press, 1995), especially Chapter 2, 'Sacred Geography:
The Holy Well'

Poll Insheen wells

Townland
Gleninsheen

Parish
Rathborney

County
Clare

The rugged limestone landscape of the Burren is home to some forty or more holy wells. They are scattered all over the region: exposed and windswept on the sides of mountains, in unexpected shady fertile vales, and in the middle of barren fields. The two Poll Insheen wells are at first barely visible, their miniature stone altars blending into the landscape. Water from these wells is said to cure toothache. Neither well is named after a saint and there are no religious objects to be found at them; coins and pieces of broken china are the only visible offerings.

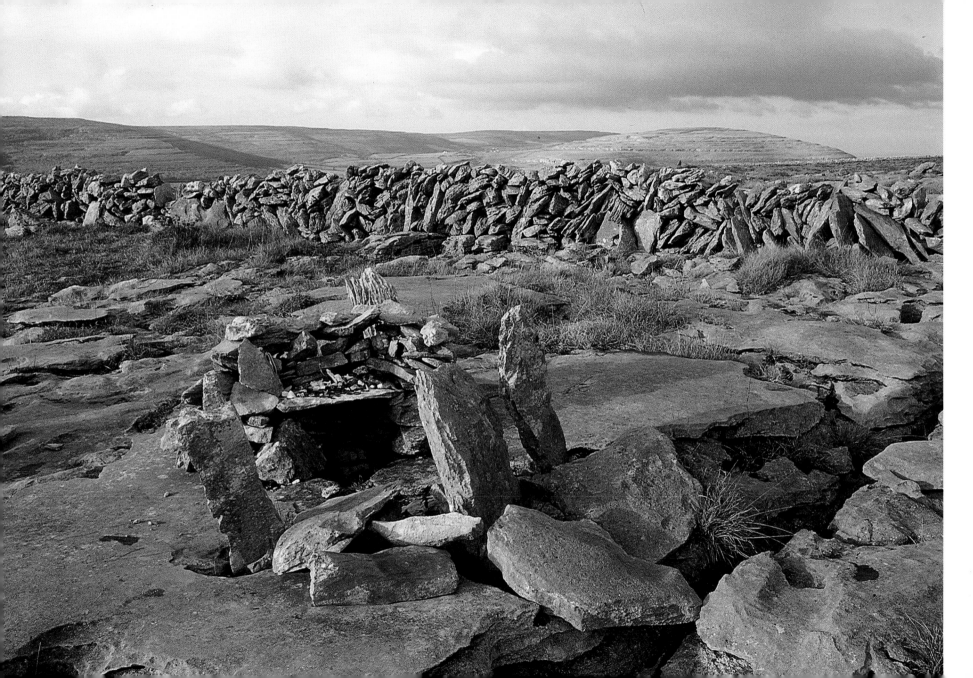

Wether's well *Tobar na Molt*

Townland
Tubbrid More

Parish
Ardfert

County
Kerry

Wether's well, or Tober na Molt, is a well-known place of pilgrimage, especially on the Saturdays before May Day, Saint John's Day and Michaelmas. The well is a large pool of clear bubbling water, beside which is the 'dressing house'. People drink the water and bathe in it, making three rounds of the well while reciting a set number of prayers. As with many wells, it is said that a trout is seen by those about to be cured. There are numerous stories about the origin of this well. Mass was said on a stone altar here in Penal times. On one occasion, the priests saying mass were surprised by English soldiers with bloodhounds, but three wethers (lambs) sprang out of the well and led the hounds away. An alternative account tells us that when Saint Brendan was baptised here three wethers sprang up from the well. Another legend is that Saint Ita travelled from Limerick to Ardfert to visit her brother, Brendan. She stopped to rest awhile at this spot, washing her face with dew and wiping it with leaves. A well sprang up at the place where she had rested.

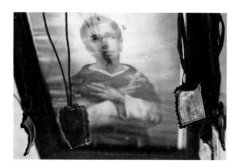

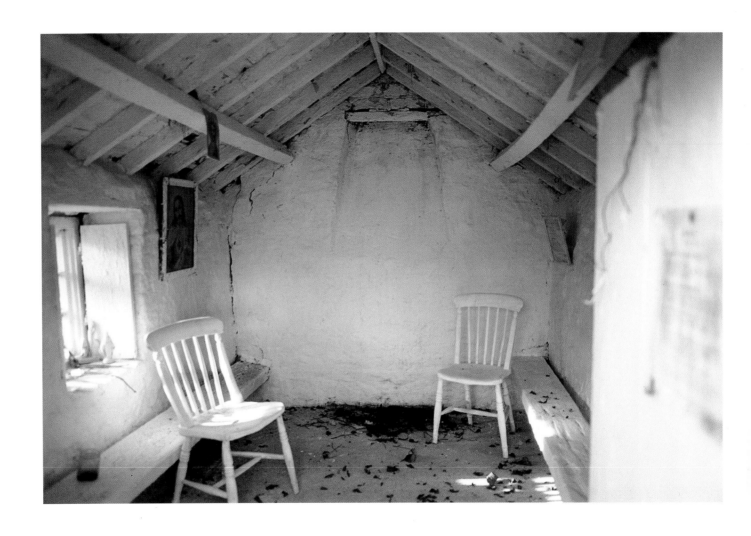

Our Lady's well *Tobar Mhuire*

Townland
Kinard

Parish
Kinard

County
Kerry

Tobar Mhuire is situated along the coast a few miles south-east of Dingle town. Pounding hail-showers swept in from the sea on the day of our visit; then the sun came out and a rainbow appeared for a few fleeting moments before we dived for cover again. Alongside *Tobar Mhuire* are *Tobar Fionáin* and *Tobar Mhichíl*. These wells are said to have sprung up when Saint Fionáin and Saint Michael said prayers after they landed here from Skellig Michael. There is a masonry cross over *Tober Fionáin*, erected in 1918 in thanksgiving for the many people who were cured by water from the wells during the great influenza epidemic.

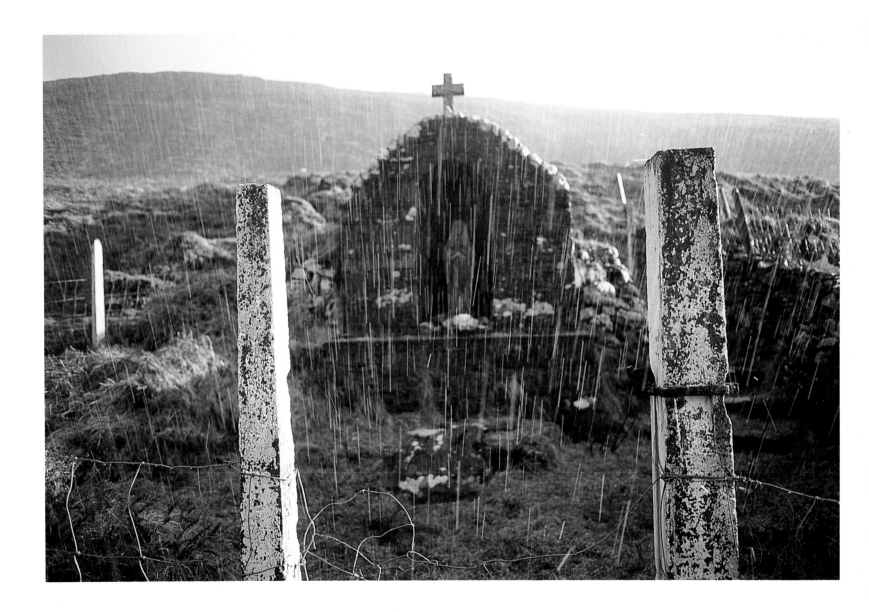

Lady's well

Townland
Lady's Island

Parish
Ladyisland

County
Wexford

For centuries Our Lady's Island has been one of the most popular pilgrimage sites in Ireland. The island is a thirty-two-acre plot of land jutting out into a tidal lake and is joined to the mainland by a causeway. Between 1740 and 1753, Pope Benedict tried to suppress Irish pilgrimages, but made an exception of those at Lough Derg and Our Lady's Island. In the latter half of the nineteenth century numbers here began to dwindle, but by 1897 a revival was underway. According to a newspaper report in 1978, crowds of 20,000 people were expected on the 15th of August. The pilgrimage involves walking around the island at the water's edge while saying the rosary, and visiting the well along the way. In olden times people were observed doing the rounds in bare feet, some with one foot in the water. Others, 'hard cases', went around on their knees in the water. If this was not penance enough, some walked eight miles barefoot from Wexford town to do the rounds. The pilgrimage season, extending from the 15th of August to the 8th of September, still attracts vast numbers of people.

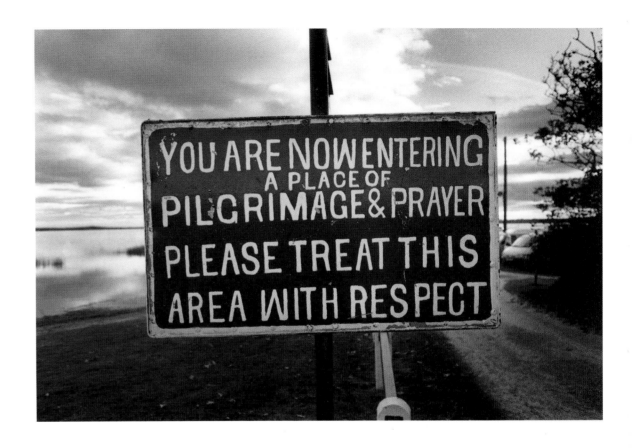

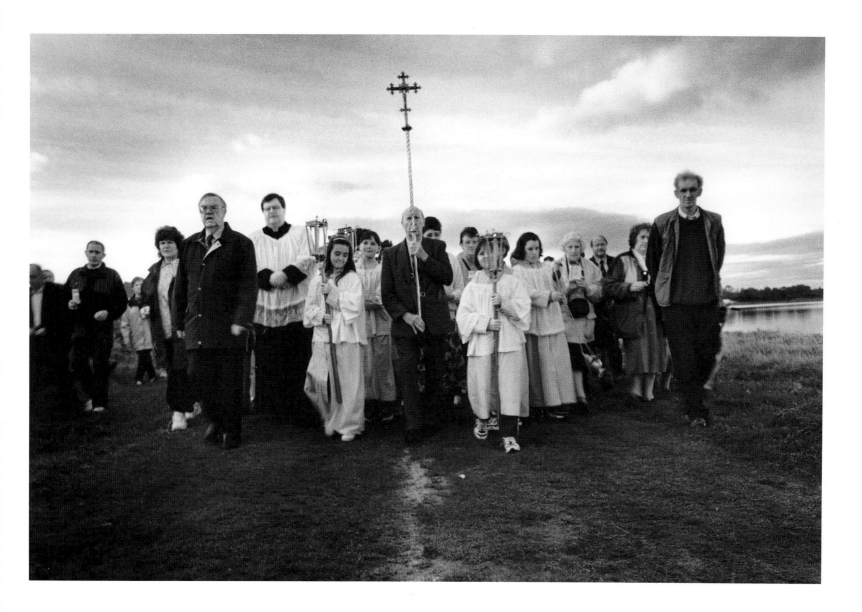

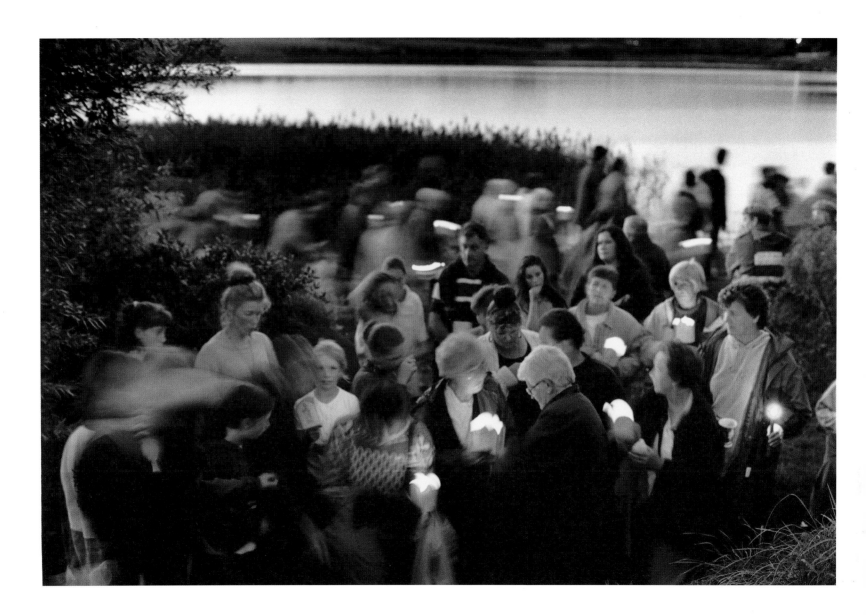

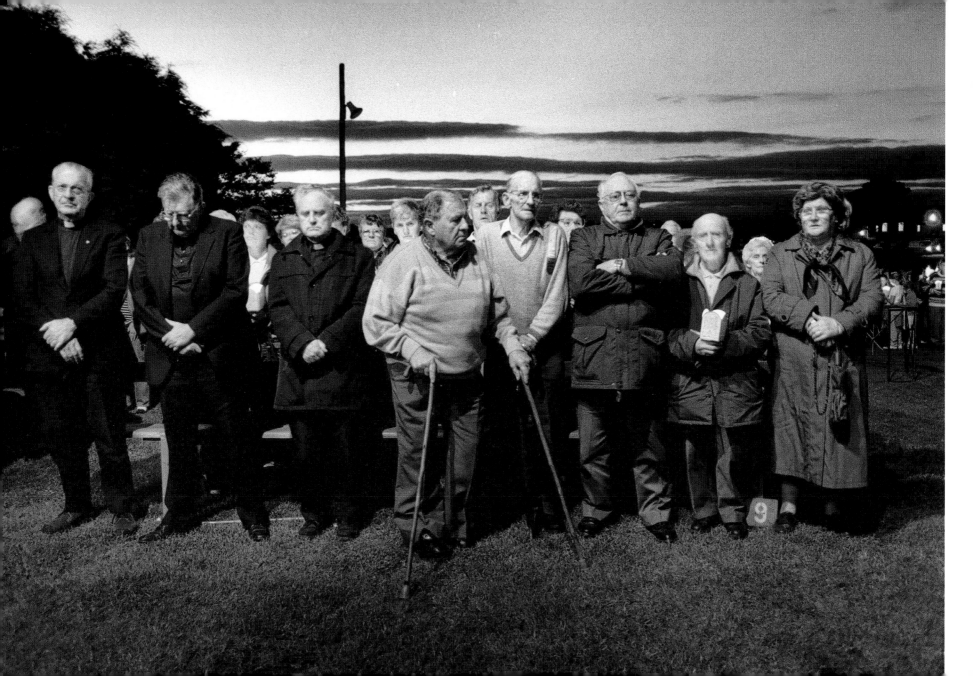

Mary's well, Saint Fechin's well
Tobar Mhuire, Tobar Feichín

Townland
Dooghta

Parish
Cong

County
Galway

Situated in the fertile valley of the Dooghta river, not far from Lough Corrib, these two wells nestle under the protective shade of a hawthorn tree. The wells are located on either side of the central 'altar', with whitewashed stone walls like outstretched arms around them. In 1839 Caesar Otway, a travel writer, toured this part of Connacht and recorded numerous stories about *Leac Feichín*, a cursing stone which is no longer at the well. To effect a curse, a person could either turn the stone in the name of the Devil or do the 'backward round' at the well. This involved walking around the well anticlockwise while saying certain prayers backwards in the name of the Devil. It is said that the person who was cursed would die within the year. However, the bad luck also extended to the person who had performed the curse. A woman called Peggy Griffin, who had performed the backward round, went mad and spent the rest of her days wandering the hills, 'speaking to the ghosts all around her'.

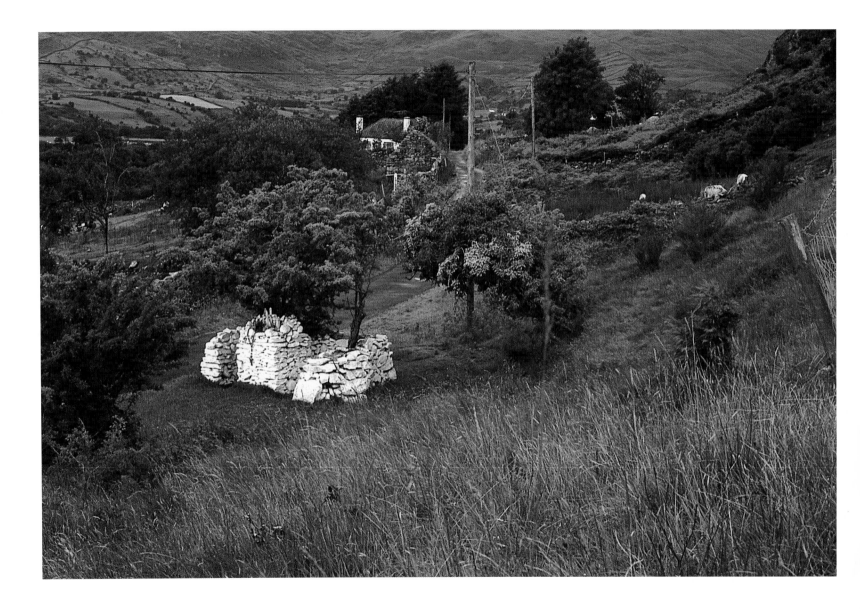

Saint Patrick's well

Townland
Patrickswell

Parish
Rathvilly

County
Carlow

According to legend, in AD 450 Saint Patrick baptised Crimthann, his wife Mell and their infant son Dathe in this well. Crimthann was pagan king of this territory and had persecuted Christians for many years. The large flagstone that partially covers the well has a crude impression of an oversized footprint in it. Tradition says that Saint Patrick stepped from this stone to Knockpatrick in County Kildare, some five miles away, leaving an impression of his foot behind. Another flagstone at the well is said to have a shamrock engraved underneath it. The well is reputed never to run dry, even in the hottest summer. The water was traditionally used to cure toothache and earache. A pattern used to be held on the 15th of August, but was discontinued in the 1870s after allegations of misconduct at it.

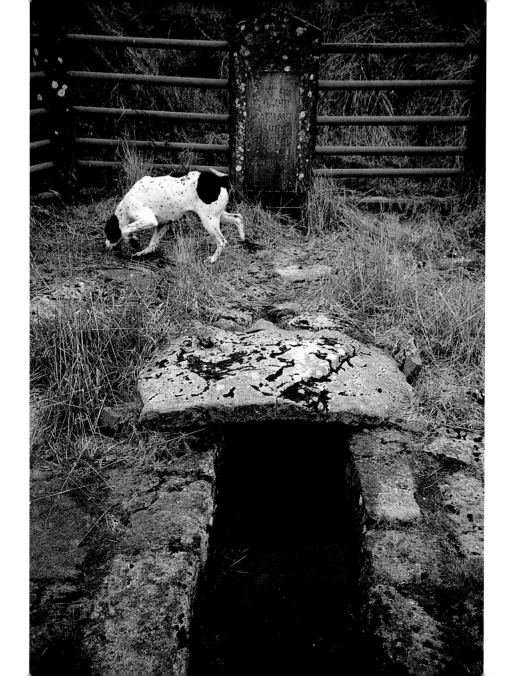

Saint Caoidhe's well *Tobar Caoidhe*

Townland
Foohagh

Parish
Kilfeeragh

County
Clare

Tobar Caoidhe overlooks the sea on high cliffs a few miles south of Kilkee. Its water is said to cure many ailments, but especially anything troubling the eyes. Water is applied to the affected part of the body, and it may be taken away for use at home. Sometimes the moss from around the well is also used for cures. The prayer rounds, nine in all, are performed going clockwise around the well; pebbles are used to count rounds along the way. If a small frog appears in the well, it is considered to be a good omen.

Saint Patrick's well *Tobar Phádraig*

Townland
Teernakill South

Parish
Ross

County
Galway

This well has a spectacular setting almost one thousand feet above sea level, in the southernmost saddle of the Maumturk mountains. The ascent to the well can be made from either side of the mountain. We followed the path from the Connemara side, as did Henry Inglis, a travel writer who climbed the mountain in 1834. He reached the well at four in the afternoon and observed the events of the pattern day. Many people, having already performed their stations, were on the way back down. Hundreds more gathered about the place, older folk doing stations, others in the numerous tents where 'the pure poteen circulated freely'. Faction fighting was not uncommon at large gatherings like this, especially when drink was involved. Inglis kept a safe distance as men poured out of tents and 'the flourishing of shillelahs did not long precede the using of them'. The pattern, still held on the last Sunday in July, is a more sober event nowadays.

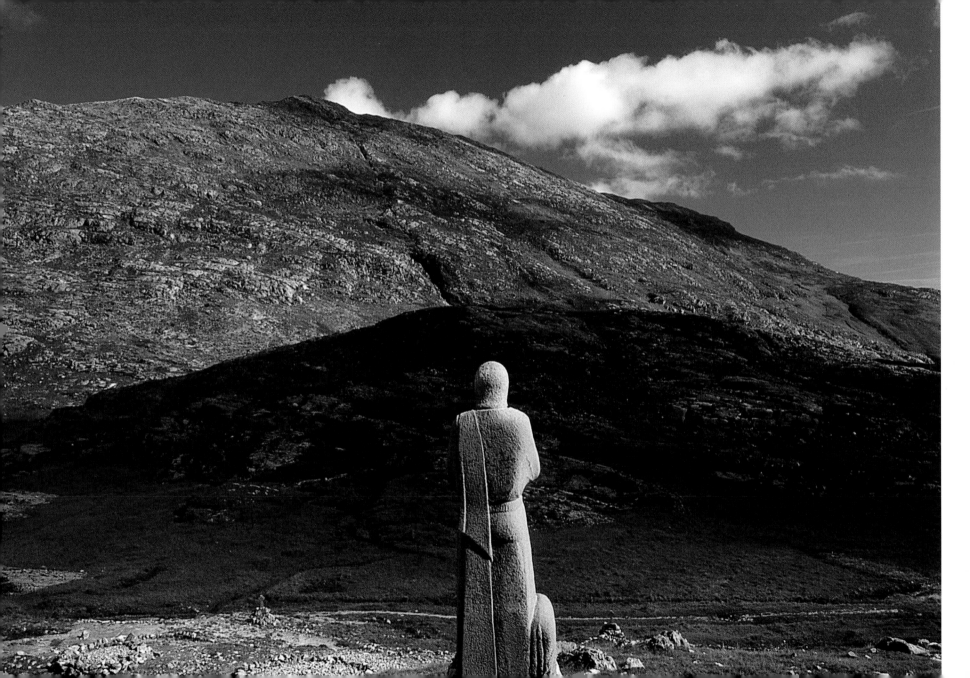

Saint Brigid's well

Townland
Riverstown

Parish
Ballybracken

County
Kildare

One of the many wells in Kildare dedicated to Saint Brigid, this one has an unusual location. Surrounded by sheds, animals and machinery, it rises up in the middle of a farmyard. The well, a bubbling pool about sixteen feet in diameter, is enclosed by a stone wall with an entrance gate in one side. Almost directly opposite the gate and lying outside the wall is a stone where Saint Brigid is said to have knelt, leaving an imprint of her knees. It is said that a man who once owned the farmyard decided to close up the well. Next morning, however, the well had overflown to such an extent that his house, some fifty yards away, was flooded with water. He promptly emptied the well of stones and built the wall around it. Patterns were once held at the well, but were discontinued over a hundred years ago.

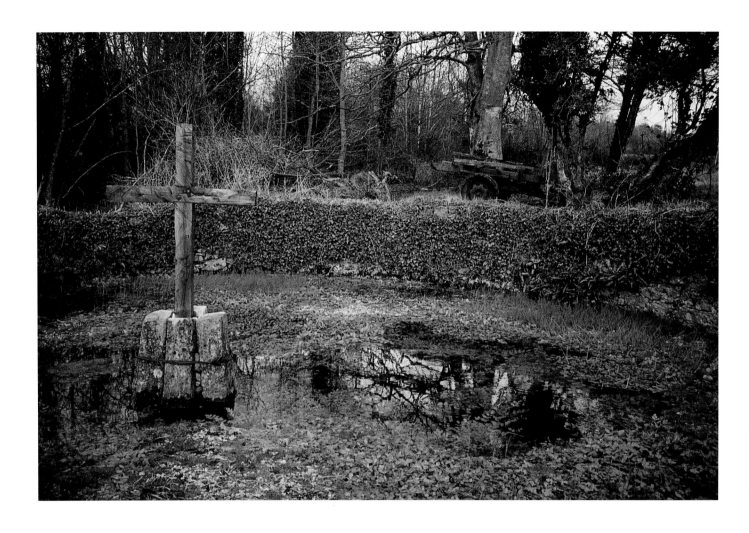

Saint Brigid's well

Townland
Ballysteen

Parish
Kilmacrehy

County
Clare

This is one of the best-known and most visited wells in Ireland. Situated at the side of the road about a mile south of the Cliffs of Moher, the well is a stopping point for the more adventurous tourist. It is at the end of a long whitewashed tunnel, profusely decorated with religious pictures, statues, poems and miscellaneous personal offerings. A blessed eel was believed to live in the well and pilgrims who saw it were assured that their requests would be answered. Anyone who interfered with this eel would die within three weeks, three months or three years. Emigrants used to take water from the well with them, to keep them safe on their journey. The pattern takes place here on the saint's feast day, the 1st of February, a day when people come to the well to perform the 'station'. This involves doing two prayer rounds, one around the statues outside the well and the other around the cross in the graveyard. Each prayer round is performed five times. On the day we visited, the crowd had thinned out by nightfall, quietness was restored to the place and the last few people performed the station by candlelight.

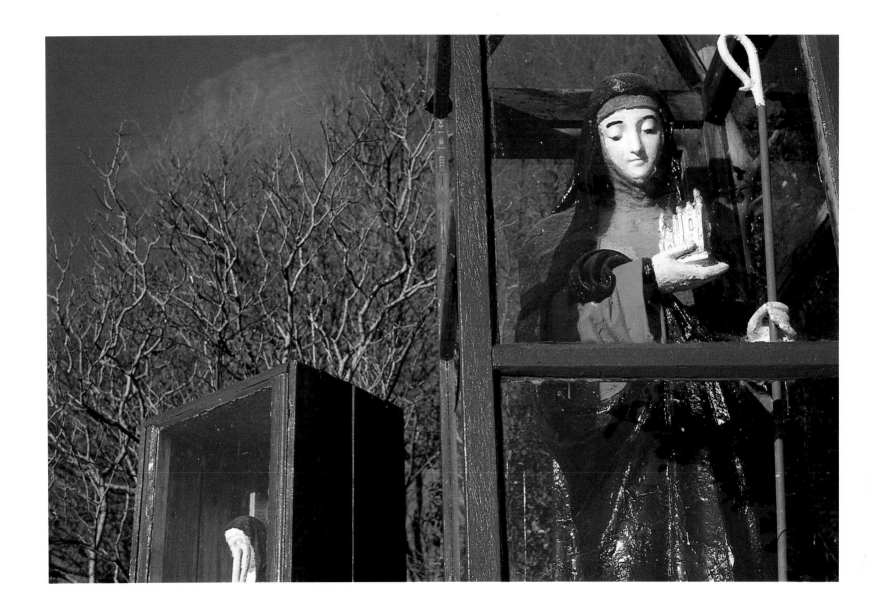

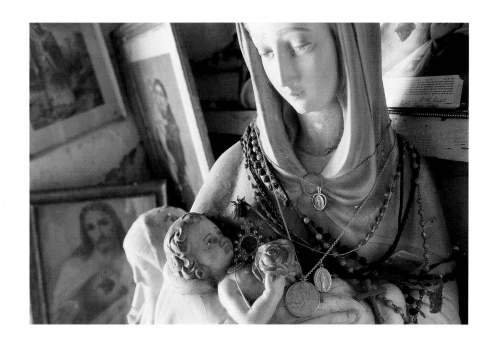

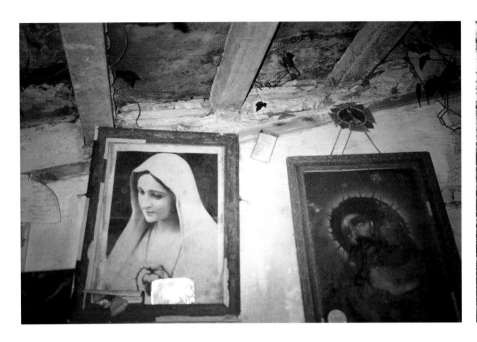
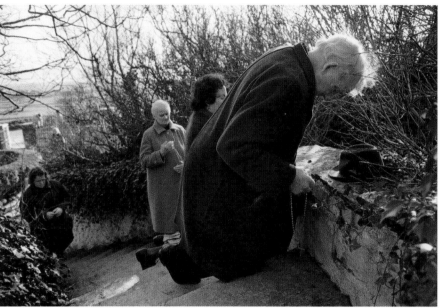

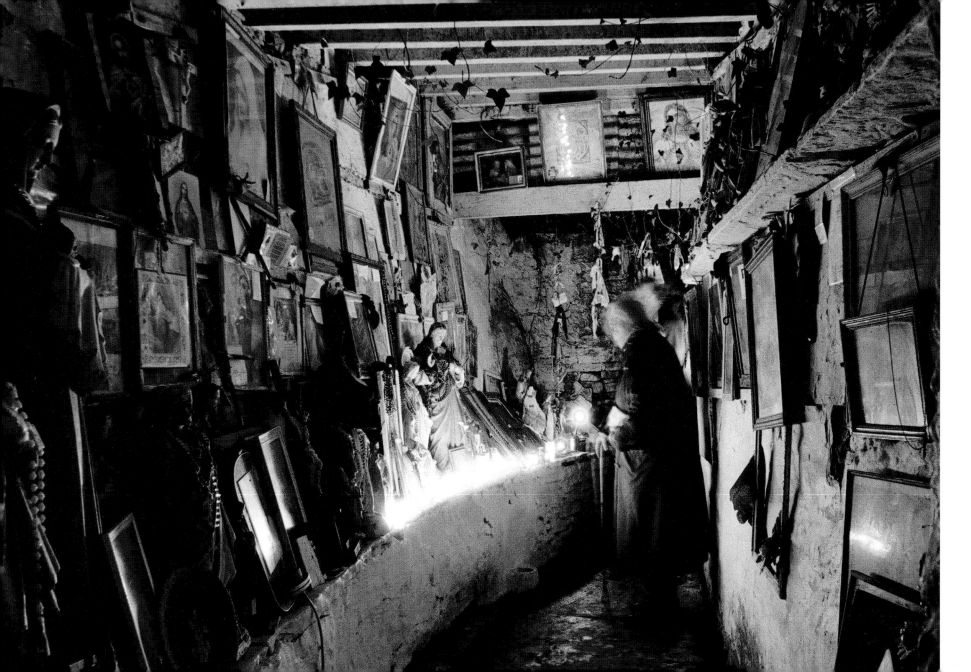

Saint Joseph's well

Townland
Dulick

Parish
Templemaley

County
Clare

Saint Joseph's well, on the outskirts of Ennis town, is bounded on one side by the southern shore of Lough Girroga and on the other by the walls of Our Lady's Hospital. The well was formerly dedicated to a local saint, Inghean Baoith, patroness of the parish of Kilnaboy in west Clare. According to John O'Donovan's Ordnance Survey Letters in 1839, the name Iníonbhaoith had been a 'favourite' name for girls in Kilnaboy parish. The saint's popularity is thought to have died out in the mid-nineteenth century and this well was rededicated to Saint Joseph. Adjacent to the well are five concrete shelters which house colourful statues of the Holy Family. Traditionally water from the well was used to cure eye ailments, and people cured of lameness left their crutches behind at the well. To obtain a cure it was customary to visit the well for three consecutive days, and if an eel appeared in the well your request would be granted.

Saint Colman's well *Tobar Cholmáin*

Townland
Slievemore

Parish
Achill

County
Mayo

Saint Colman's well nestles amongst the headstones of Slievemore graveyard in the north of Achill Island. Behind the well, lazy beds and broken walls rise up to the foot of Slievemore, the highest mountain on the island. Nearby stand the ruins of the 'Deserted Village', a bleak reminder of a time when famine, emigration and eviction left an indelible mark on the area. A fish is said to live in this well. A pilgrim must walk around the well seven times, recite seven rosaries and throw seven stones into the water. If the fish appears it portends good fortune. In the past people washed their feet in the well to ensure good health.

Skour well

Townland
Highfield

Parish
Creagh

County
Cork

A steep stretch of road winds its way down into the wooded valley that surrounds Lough Hyne, a few miles east of Baltimore. The well lies half a kilometre north of the lake along the roadside. The name of the well Skour or *Sceabhar* may relate to its location at the foot of a hill; *sceabha* in Irish means slope or slant. A pattern takes place here on May Eve. In former times people made rounds at the well, counting each round by dropping a white stone into the well. Nowadays the local priest says mass at the well instead. The hawthorn tree overhanging the well is decorated with an eclectic mixture of religious and personal offerings. Traditionally, rags were used to wash the afflicted part of the body with water from the well and were then tied to the tree or bush. As the rag deteriorated, the pain faded away. In some parts of Ireland, when the rag is tied to the tree, the tree itself 'takes on' the pilgrim's pain.

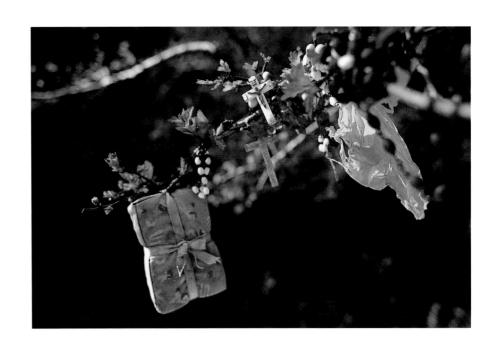

Mary's well *Tobar Mhuire*

Townland
Killarga

Parish
Killarga

County
Leitrim

We attended the pattern here on the 15th of August, the feast of the Assumption, which began with a procession from the church in Killarga village to the holy well on its outskirts. Many people had already gathered at the well, the early arrivals having availed of the much sought after temporary seating. About two hundred people attended the outdoor mass. The rain held off until the very end of the ceremony, and even then the canopy of trees surrounding the well provided reasonable shelter. After mass, people joined in the friendly jostle to light a candle or get a drink of water from the well. Here we were informed the water cures many ailments, including arthritis, depression and even cancer. We were also told how the Virgin Mary appeared here to a local man one hundred years ago. It was colourfully related to us that the Virgin was seen 'flying around the field'. The congregation dispersed quickly to avail of the refreshments provided in the community hall.

Saint James's well

Townland
Carrownyclowan

Parish
Shancough

County
Sligo

Saint James's well lies close to a stream on the slope of a ridge of hills called the Bralieve mountains. There seems to be no obvious route down to the well. A graveyard, a field, a stream and a tract of forestry have to be crossed before you get the first glimpse of it. Traditionally people did stations here between the 25th of July and the 15th of August, the special days of devotion being Sundays and Fridays. The station involved walking around the well three times saying three decades of the rosary, taking a drink of water to finish. Some people washed their hands and face in the stream beside the well afterwards. The area is rich in mythological lore; a famous battle is said to have taken place between the Celtic god Lugh and his evil grandfather, Balor, on the other side of the glen. Balor had a 'fearsome' eye, and Lugh, using a slingshot, drove the eye into the back of his head. Legend also tells us that the ruins of an old church nearby were removed overnight by supernatural forces.

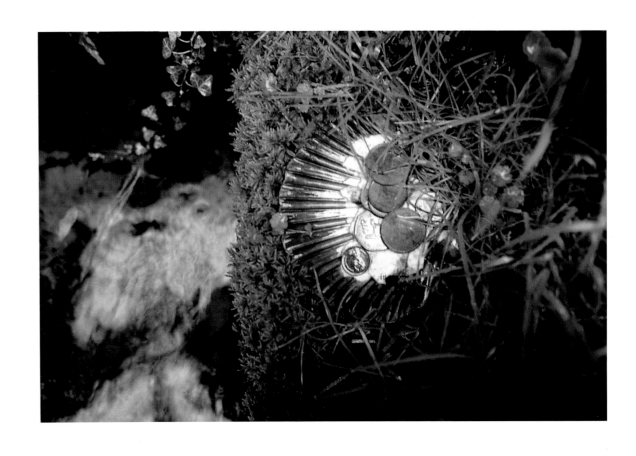

Tobar Ogulla

Townland
Ogulla

Parish
Ogulla

County
Roscommon

According to the Book of Armagh, Saint Patrick and his followers met the pagan daughters of the High King Laoghaire when praying early one morning near this well, which was then known as the fountain of Clebach. The girls thought Patrick and his companions were ghosts. Fascinated by their unusual dress, they inquired to know more about them. Saint Patrick proceeded to tell them all about God and Christianity. The daughters, struck by his words, asked to be baptised into the faith there and then. Patrick obliged and baptised them in the waters of the well. The sisters then asked to see the face of their Christian God. Patrick explained they could do this only through death, but they were resolute. So he administered the Eucharist and the girls then 'fell asleep into death'. In 1974, pilgrimage to this place was revived, and the pattern takes place every year on the last Sunday in June. The glass oratory was specially built for Pope John Paul II when he celebrated mass at Knock in 1979. The Ogulla Well Committee purchased the steel and glass structure in 1980 and erected it beside the well.

Saint Moling's well

Townland
Mullennakill

Parish
Jerpoint West

County
Kilkenny

This well is found in a steeply sloping field overlooking the pastoral valley of the Arrigle river, just four miles south of Inistioge. When we visited, bunting had been hung around the field for the pattern on the 20th of August, the saint's feast day. People leaned up against the railing by the side of the road to take part in the proceedings down below. Locals informed us it is considered unlucky to harm the hazel tree that stands over the well. A man once tried to chop it down for firewood. While chopping, he saw in the distance that his house was in flames. He hurried to it, only to find there was no fire there after all. So he went back to cutting down the tree. Again he saw his house on fire, but this time he ignored it and went on chopping. When he returned to his home, he found it had burnt to the ground. Nowadays people take a piece of bark from the tree to protect their house from fire for the coming year. We were also informed that water from the well is said to cure warts, sore throats and eyes, and the stone bowl beside the well is used for washing feet to cure foot ailments. Legend has it that Saint Moling was chided by a local woman for bathing in the well; irritated by her lecturing, the saint predicted that a rogue or a fool would always be found in Mullennakill.

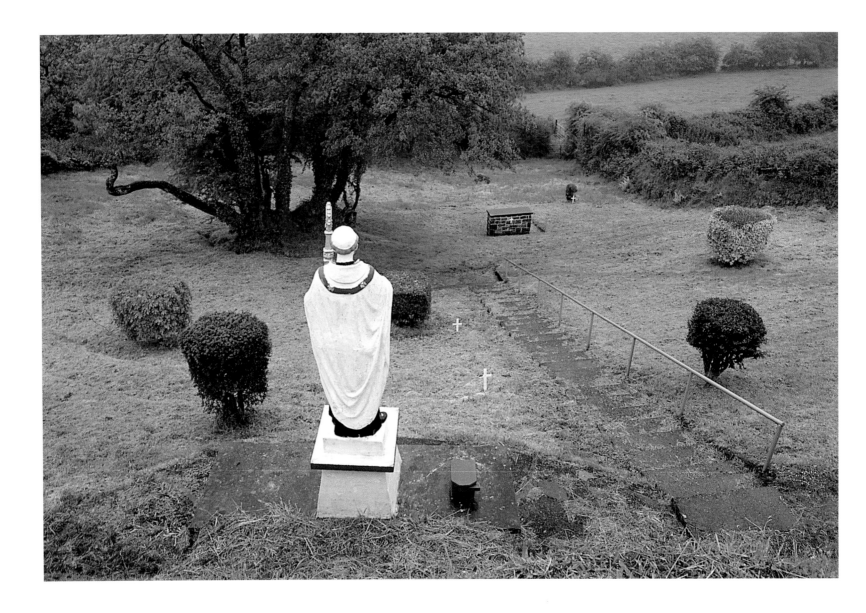

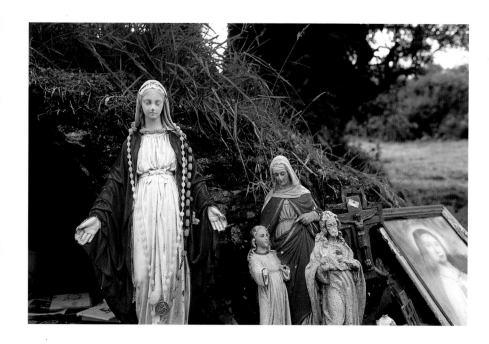

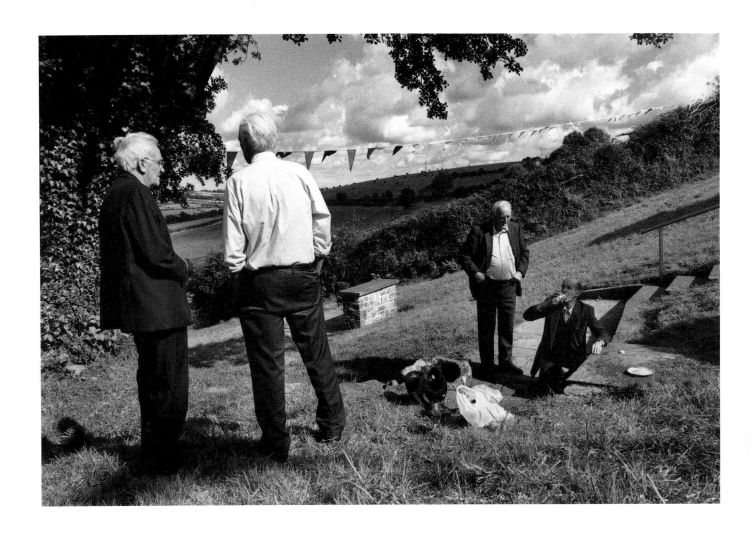

Saint Patrick's well

Townland
Dromard

Parish
Dromard

County
Sligo

This well is situated in the foothills of the Ox mountains, a short distance from the Sligo coast. It is visited all year round, but especially on its pattern day, the 29th of June, when a mass is said. In former times people assembled at the well on the eve of the pattern, popularly known as the 'gathering evening'. In those days the pattern went on for nine days, the pilgrims returning each day to do the rounds. Many walked from as far afield as Ballymote, twelve miles away. Hairpins, crutches and eyeglasses were routinely left behind as offerings. The water is said to cure eye and skin ailments, and another well outside the enclosure is used for the washing of feet before the pilgrim begins the rounds. A rock on top of the hill overlooking the well is said to cure backache. A pilgrim must walk around the rock three times, saying three Hail Marys, sitting on the rock each time. According to folklore, Saint Patrick rested his back against this rock while he was building the wall around the well. Bark from a tree over the well was used to relieve backache and water from the well was believed to cure blindness, deafness and lameness.

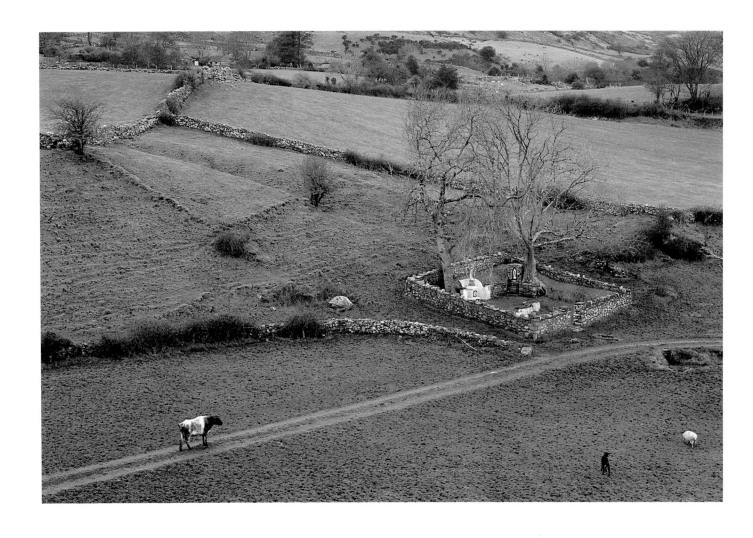

The Blessed Well

Townland
Kilgeever

Parish
Kilgeever

County
Mayo

The Blessed Well and station of Kilgeever are located in a graveyard a few miles from the well-known pilgrimage site of Croagh Patrick. A plaque at the entrance to the graveyard describes the traditional station here. It begins with a round of the holy well where seven Paters, seven Aves and the Creed are said while kneeling in front of it. Worshippers circle the well seven times, saying further prayers and counting the rounds with stones. The pilgrims then proceed to three flagstones near the well and mark the sign of the cross in each one. (The tradition of inscribing crosses in stones is practised at some other holy wells, most notably Saint Gobnait's at Ballyvourney in County Cork and Saint Declan's at Ardmore in County Waterford.) Further prayers are said before returning to the well along the edge of the stream. However, if the station is being done for a living person the pilgrims should walk back in the stream. A trout is said to appear in the well if the prayers are to be answered.

Angels well *Tobar na nAingeal*

Townland
Bindoo

Parish
Kilteevoge

County
Donegal

A few miles west of Ballybofey, the road winds along the river Finn before turning south into the foothills of the Blue Stack mountains. The well is situated on the roadside and, when we visited, a small number of people had gathered early, to perform the station before nightfall. The pattern takes place annually at midnight on May Eve and the curative powers of the well are said to be most powerful at this time. Seven rounded stones placed behind the well are used for healing. The women passed each stone in turn around their heads, arms, legs and torsos, blessing themselves with the stone and kissing it to finish. The well acquired its name during Penal days when a Holy Friar, Bráthair Ó Buí, was caught by priest-hunters in the area. The priest requested that he be allowed to walk in front of his captors, and when he got to the well he knelt down and prayed to the angels. The well and the priest became enveloped in a thick fog and angels with torches gathered round him. His pursuers, lost in the mist, came upon the site but could not see him and passed on by.

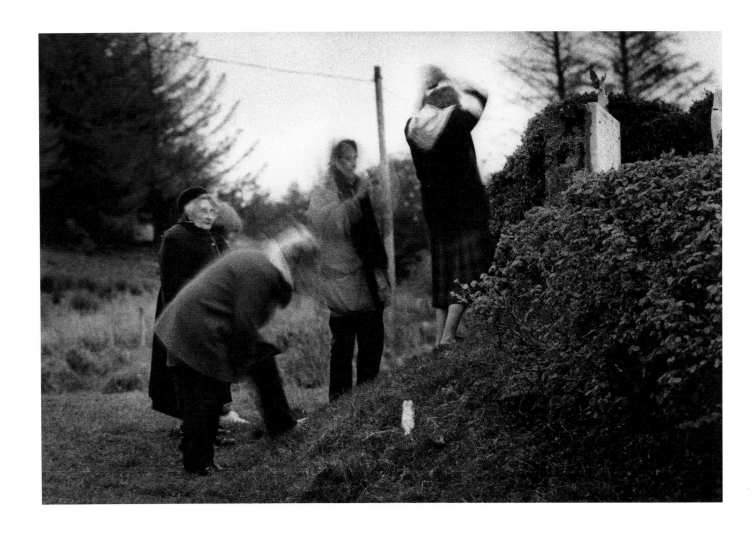

Saint Flannan's well

Townland
Drimanure

Parish
Inagh

County
Clare

This well is lovingly kept. Candles are lit in the well-house, and religious pictures and statues are carefully arranged in the remains of old washing-machines and plastic containers which hang on the trees surrounding the well; each little 'altar' is decorated with seasonal flowers. According to the present keeper of the well, the old ash tree has always been known as the 'unusual tree'. He told me that many years ago he and his wife had had six daughters, but longed for a son. They prayed daily at the well for a son and in time their prayers were answered. Their boy was duly named Flannan. It is said the well cures headaches and lameness, and if an eel appears in the well your request will be granted. Legend has it that Saint Flannan passed this way when travelling from Killadysart to Galway; he stopped in Mauricesmills and blessed the well, leaving the imprint of his feet in a stone nearby. I was also informed that water from the well will not boil and that the pattern on the 18th of December is still very popular.

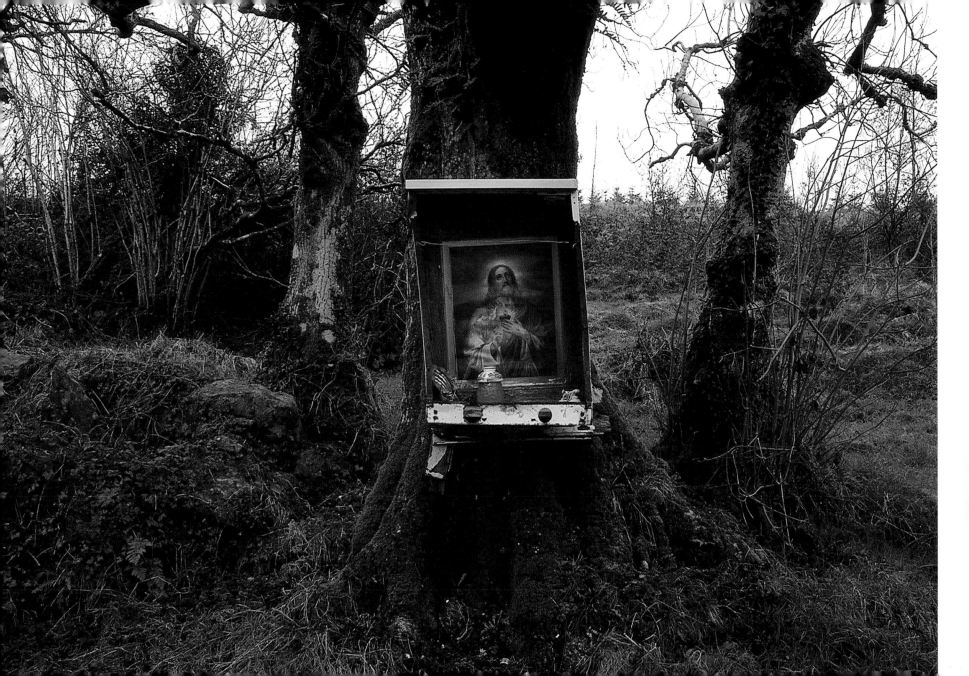

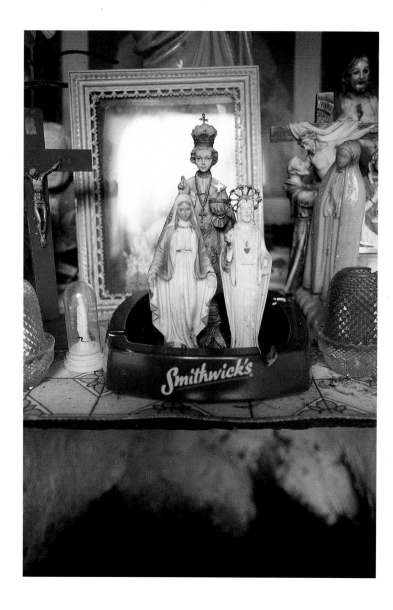

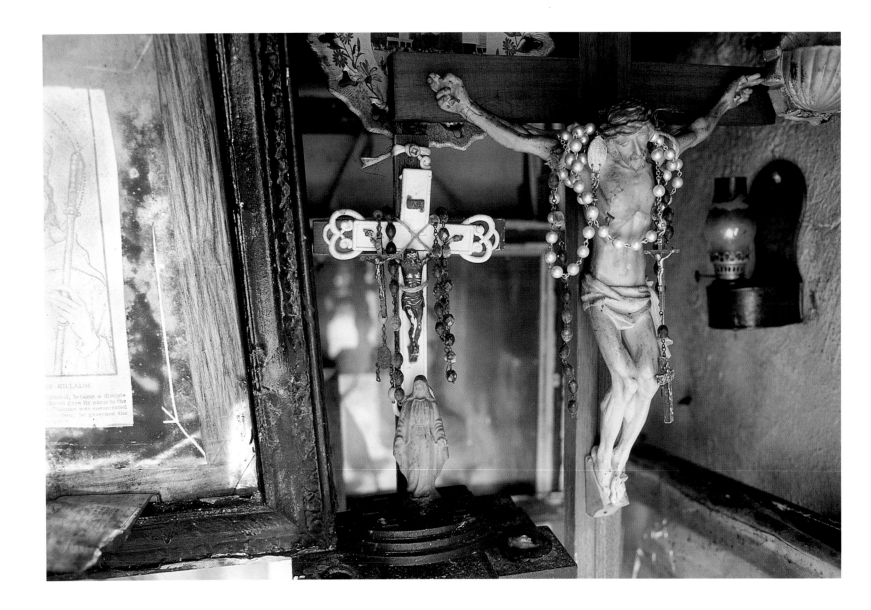

Saint Kieran's well

Townland
Castlekeeran

Parish
Castlekeeran

County
Meath

This group of wells is about three miles west of the historic town of Kells. The small country road beside the well quickly filled up with cars on pattern day, the first Sunday in August. People knelt or sat on the small hill rising up behind the well while prayers were led by the local priest. Afterwards visitors sought cures in the various wells, chatting to friends and neighbours along the way. One well cures toothache, another headache, and washing feet in the stream protects against foot ailments for the coming year. The healing power of the water is said to be at its height from midnight to midnight on this day. Beside the well is a hollowed rock that Saint Kieran is said to have sat in; it is believed that sitting in it three times will cure or prevent backache. Three trout are said to live in the well and only appear for a few minutes at midnight before the pattern day. Sir William Wilde, the antiquarian and surgeon, reported seeing them when he visited the well in 1849. A large ash tree stood over the well in those days and, according to Wilde, about ten years earlier there were reports that the tree was bleeding. Thousands of people flocked to witness the miracle and collect the 'blood' to use for cures. The tree decayed and fell sometime in the early years of the twentieth century.

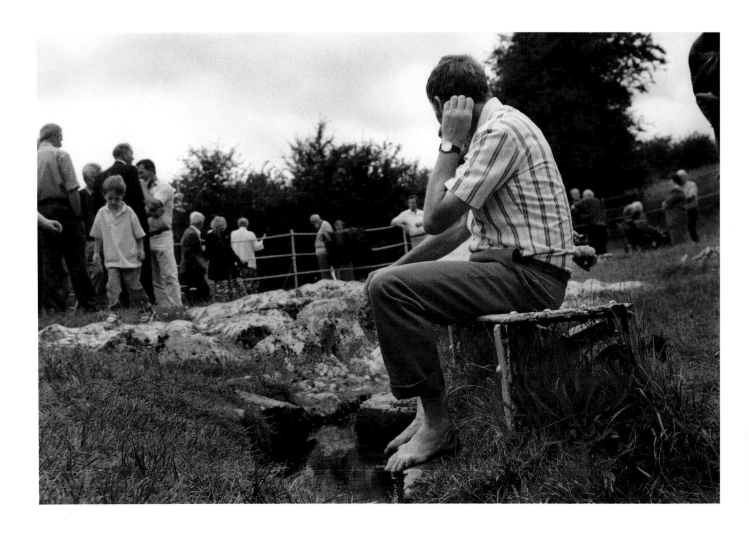

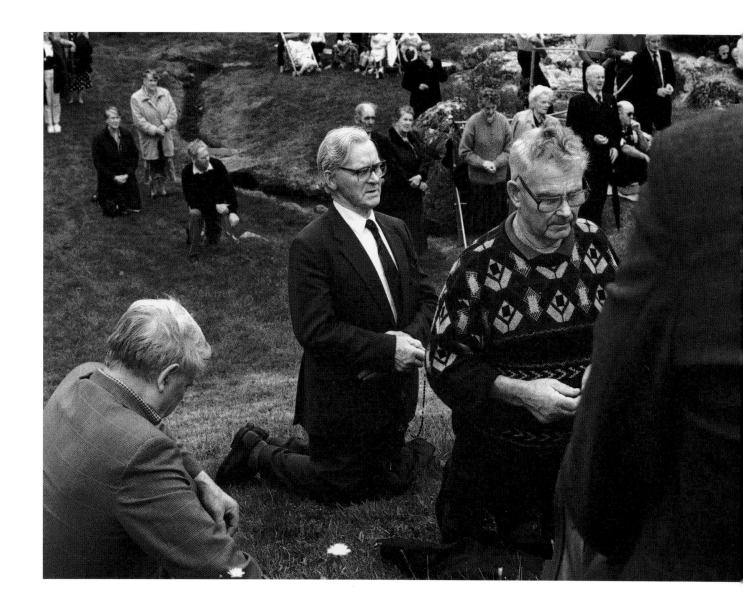

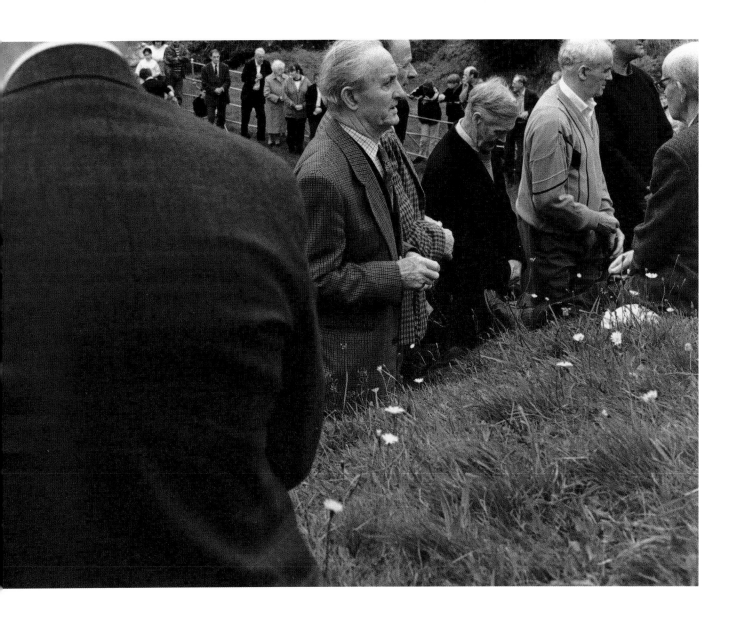

Saint Ciarán's well

Townland
Bavan

Parish
Kilcar

County
Donegal

Although situated at the roadside, this well is easily overlooked. Only the head of the saint is visible from the road, and he appears to be peeping over the verge at the passing traffic. When we finally located the well, the low cloud slowly lifted to reveal a rich, rusty winter bog. The well is dedicated to Saint Ciarán of Saighir, considered to be one of Ireland's first saints, born in west Cork about the year AD 375. He settled as a hermit in the woods in Saighir, near Clareen in County Offaly, and a wild boar is said to have helped him build his hut by cutting down branches with his tusks. Soon his hermitage became a thriving monastery, known as Seir Kierán, and later it was a burial place for the kings of Ossary. Of the many miracles he performed throughout his life, Saint Ciarán was best known for raising the dead to life. Traditionally the pattern took place here on the saint's feast day, the 5th of March.

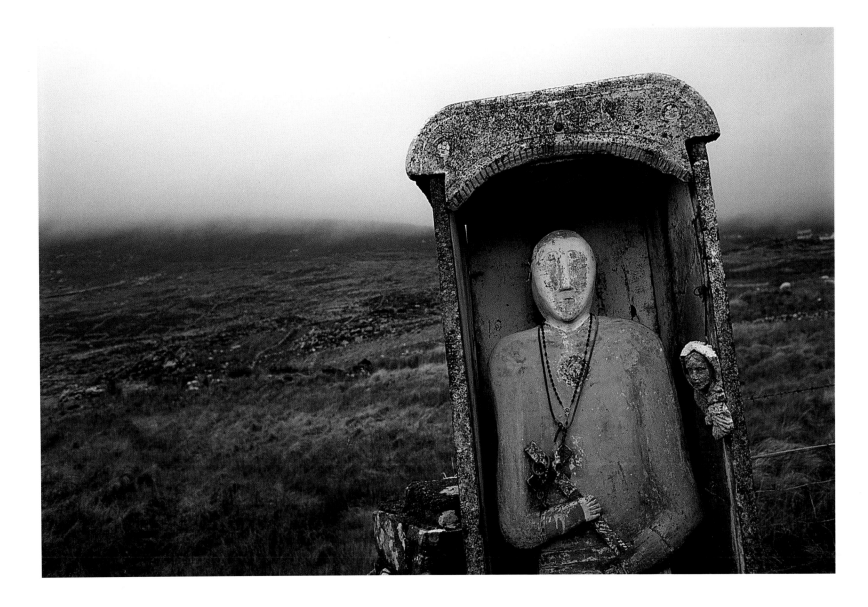

Saint David's well

Townland
Ballynaslaney

Parish
Ballynaslaney

County
Wexford

This well has long been resorted to as a special place for cures. In the early 1800s its water was sold as a cure for various diseases. In 1840 the farmer who owned the land covered over the well and levelled the old well-house; however, the grass would not grow over it and eventually, in 1910, the well was reopened. Today there are two wells on the site; the smaller one in the well-house is said to have 'the cure'. The well-house is also home to numerous 'intentions' books, a feature apparently unique to this well. The hundreds of requests from young and old alike are a remarkable testimony to the many people who still place their faith in Saint David. It is moving to find the scribbled notes of gratitude for a request that has been answered. A pattern still takes place here on the 1st of March, the saint's feast day.

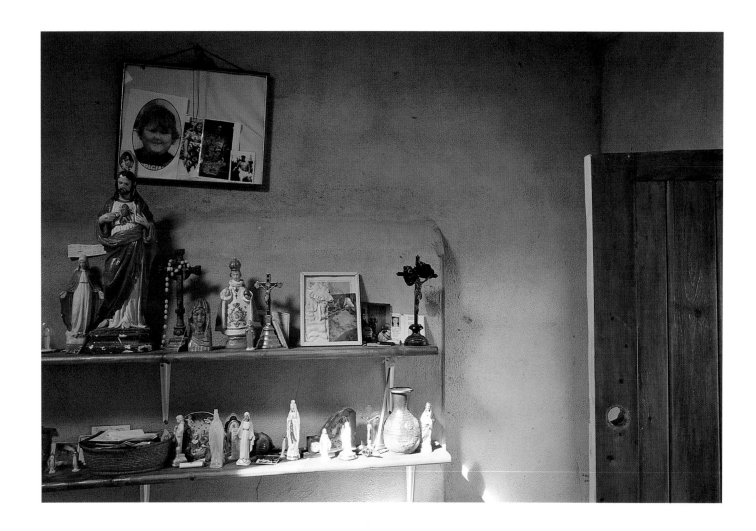

Saint Manchan's well

Townland
Lemanaghan

Parish
Lemanaghan

County
Offaly

Saint Manchan was born in Mohill, County Leitrim, but spent the greater part of his life in Lemanaghan, where he founded a monastery near this well in AD 642. According to legend the saint owned a famous cow that supplied milk for all the inhabitants of Lemanaghan. One day some people from nearby Killmonaghan stole the cow, and by the time Saint Manchan found her, she was already in the pot being cooked. With only the cow's hide remaining, he performed a miracle and restored the cow to life. To this day, as a mark of respect to the saint, the people of Lemanaghan will not produce milk for sale, and any surplus milk is usually given away. To obtain a cure at this well it was customary to visit it on three consecutive Fridays, at three o'clock sharp. Water was taken from the well and put into a stone font nearby. The person then blessed him or herself with the water and said one Our Father and three Hail Marys. On the last Friday the pilgrim climbed through a window in the monastery ruins and left something, such as a penny or a pin, in the font. The well is still visited on its pattern day, the 24th of January.

Saint Michael's well

Townland
Tinnahinch

Parish
St Mullins

County
Carlow

A fire-grate provides a railing for the miniature statues of Saint Bernadette and Michael the Archangel, and an old iron bed-end makes an inventive and decorative entrance gate. Access to the well, situated on the banks of the river Barrow, is across marshy land. Very little is known locally about the well, though it is still occasionally visited. A pattern is held in the nearby graveyard on Michaelmas, the 29th of September, but it has been many years since a visit to the well was part of the ritual. A local woman told me her grandfather was cured of eye trouble years ago; he subsequently dedicated a great deal of time to looking after the well. Formerly, a special novena was performed to invoke a cure and there was also a tradition of saying a 'protection prayer' to Saint Michael.

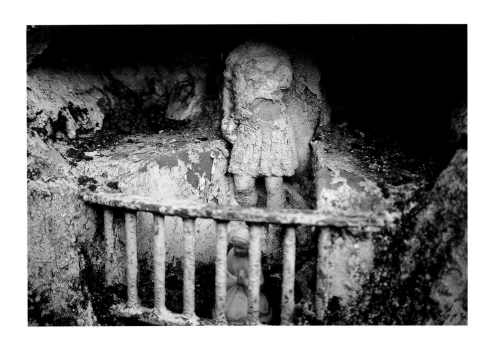

Saint Columcille's well

Townland
Beefan

Parish
Glencolumcille

County
Donegal

The short, steep climb up to this well is rewarded with fine views of Glencolumcille valley all the way out to the cliffs at Rossan Point. Columcille, also known as Columbanus meaning 'Dove of the Church', was born in Donegal in AD 520, and is one of the most revered of Irish saints. The special day of pilgrimage here is the 9th of June, the saint's feast day. The three-mile-long *turas*, or round, takes in much of the valley, stopping at various penitential stations along the way before culminating at the well. It is performed three times and can take up to three hours to complete; some people make the rounds in bare feet. As part of the *turas* people walk around a 'holed pillar stone'; if they look through the hole towards the southeast, and are in a spiritually pure state, it is said they will get a glimpse of heaven. A local man told me that many years ago a woman was struck blind when she filled the hole with earth. He also said there used to be two small stones at the well, one of which cured headaches and the other sore eyes. These were 'borrowed' some time ago and never returned. It is said that if you see a trout in the well you will die within a year.

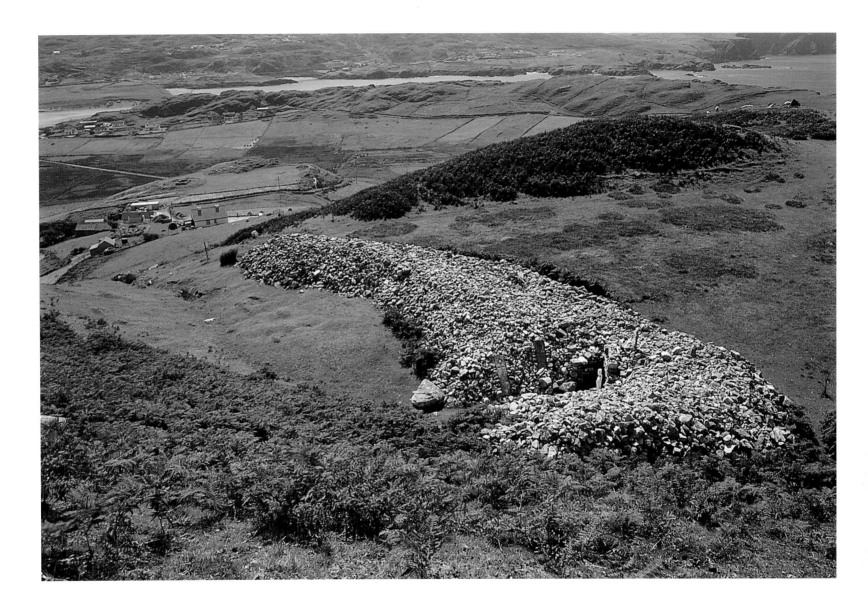

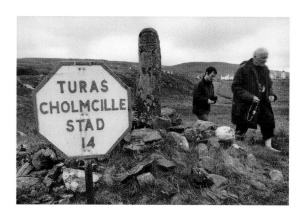
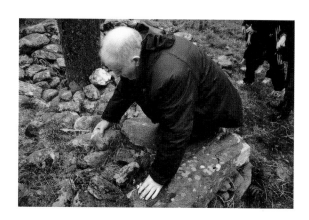

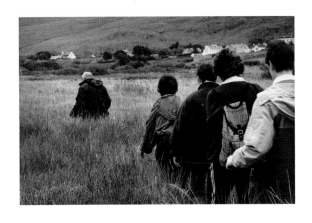 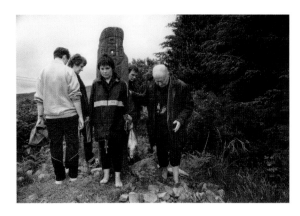

Saint Ceannanach's well

Townland
Clooncree

Parish
Ballynakill

County
Galway

Along the roadside three miles west of Cleggan is Saint Ceannanach's holy well. Enclosed by a circular stone wall, with an entrance to the north, the well is filled with cool, clear water. Very little adorns the well, apart from the flourishing plant-life of late summer. Saint Ceannanach is thought to have been the son of a Leinster king and one of the earliest Christian preachers in the extreme west of Ireland. He lived locally but travelled to Inis Meáin, one of the Aran Islands, where the ruins of an oratory called Teampall Ceannanach and a holy well remain. According to legend, the saint was seized by order of a pagan chief and beheaded somewhere near Cleggan. Ceannanach carried his own head to this well, where he washed it and put it back on before lying down to die. Saint Ceannanach's Stone is said to mark the spot of his beheading. This story may have inspired the saint's name, Ceannanach, the Irish *ceann* meaning head.

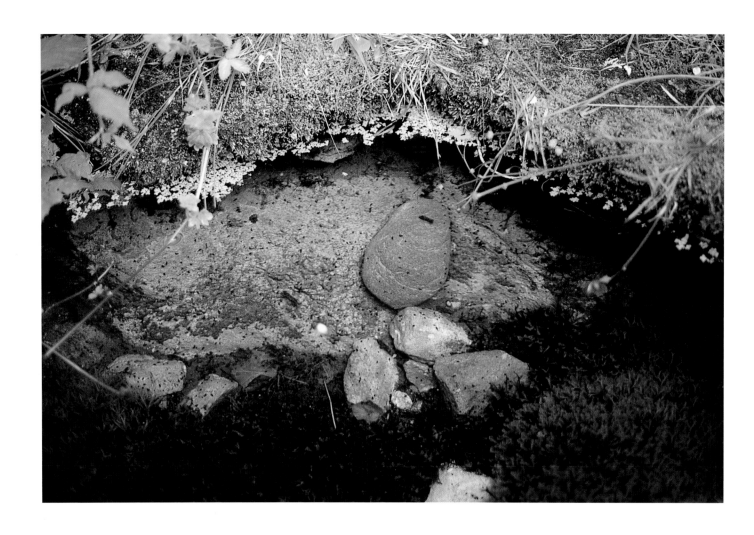

Saint Fechin's well *Tobar Feichín*

Townland
Cammanagh

Parish
Ross

County
Galway

Saint Fechin's well is situated at the foot of Benbeg mountain, and on the day we visited it was hidden amongst the dense fern growth of late summer. Rain fell in a light but persistent drizzle that day and it looked as though it was not going to let up. We waited a while and eventually our patience paid off as the mist cleared just enough to reveal a silvery slip of Lough Mask in the background. Very little is known about Saint Fechin's life except that he founded six monastic settlements, including one at Fore in County Westmeath and another at Cong in County Mayo, eleven miles east of this well. Fechin died at Fore in the terrible plague that swept across Ireland in AD 665. Saint Moling had a vision that all the demons of Ireland, terrified by the bright light that suffused the island at the time of Fechin's death, fled the country for a time.

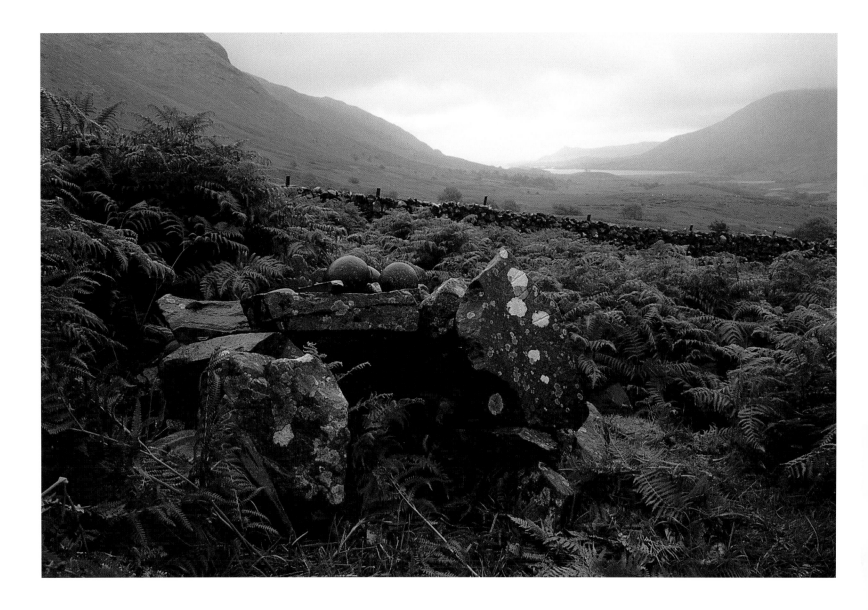

Saint Patrick's well

Townland
Cartron

Parish
Granard

County
Longford

It is said that when Saint Patrick visited this well he found druids performing ceremonies there. A chieftain from a neighbouring parish invited Patrick for a meal, which was not lamb as promised, but cooked dog. The saint, offended by the intended insult, is said to have cursed the area with barrenness and destitution. He then blessed the food; and the dog, restored to life, jumped up off the table and ran away. The townland where this happened is known as *Achadh na Madadh*, meaning 'Field of the Dogs'. According to local tradition, a woman once washed clothes in the well; the well, having been profaned, moved to another part of the field. People still visit on pattern day, the 15th of August; however, another Patrick's well near here is regarded as the one with 'the cure', particularly for warts.

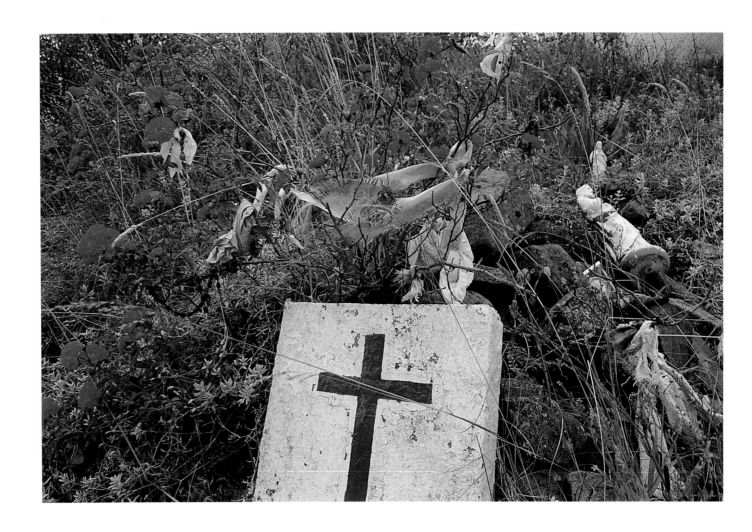

Saint Kieran's well *Tobar Chiaráin*

Townland
Kilkieran

Parish
Moyrus

County
Galway

Situated on the side of a small hill, above Kilkieran village, this well is still frequented for its curing powers. Water from the well is believed to relieve pain when applied to sore limbs; if you are very sad, it is said you should do the rounds until your sadness lifts. The annual pattern takes place on Saint Kieran's feast day, the 9th of September. We watched as, after mass in the local church, people said decades of the rosary while doing rounds of the well. The crowd then made their way up to Saint Kieran's bed, a place where the saint is said to have slept and celebrated mass. One or two people did further rounds here, while others admired the view of Kilkieran Bay. Afterwards a few people went for a pint in the local pub and later that night a dance was held on the pier.

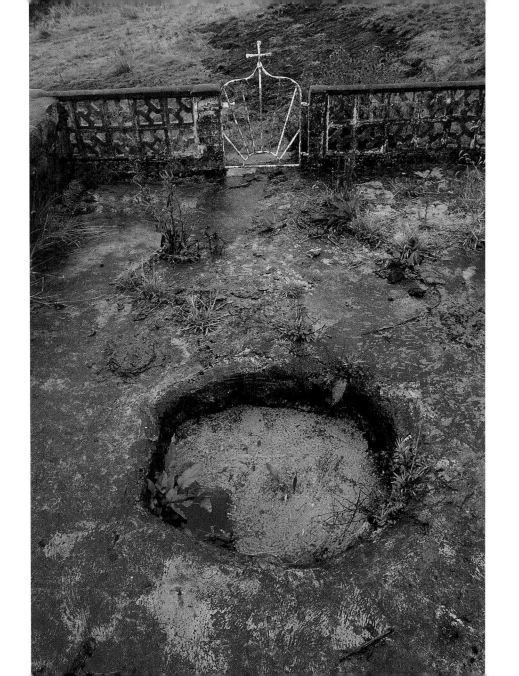

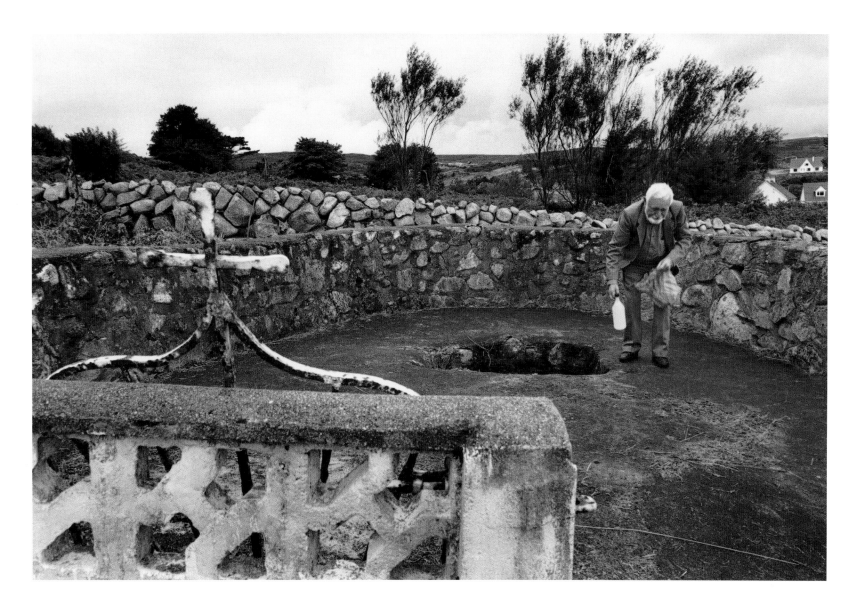

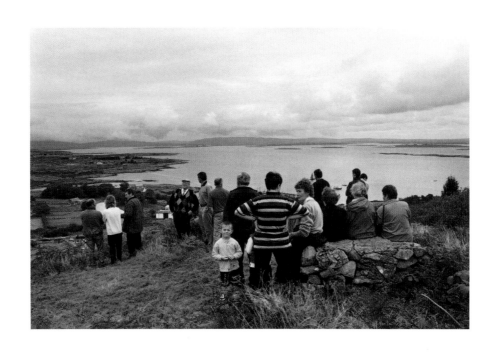

Saint Colman's well

Townland
Cranfield

Parish
Cranfield

County
Antrim

Saint Colman's well and 'clootie tree' stand close to the ruins of Cranfield church on the north shore of Lough Neagh. Protected from the elements by a high circular hedge, the tree is adorned with an assortment of offerings, everything from plastic bags to socks and crisp bags, its branches barely visible under the clutter. The well is renowned for the small brown crystals, known as 'Cranfield pebbles', that are found in it only on May Eve. The crystals are said to protect a person from drowning and women against difficulties in childbirth. The pattern, traditionally held on May Eve, is thought to have died out over two hundred years ago.

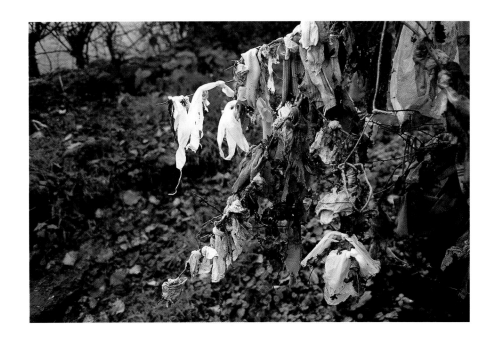

Saint Patrick's well

Townland
Carlanstown

Parish
Kilbeg

County
Meath

From a distance, hidden from view amidst the meadow grass, this well has the appearance of a small natural mound. Only when we were almost on top of it did this beautiful but simple structure, which forms the roof of the well, reveal itself. The entrance into the well is reached by clambering down the other side of the mound; here through a small archway access to the water is gained. The water is clear and fresh, but the place is no longer visited and the pathway to it is very overgrown. Legend has it that Saint Patrick stopped in Carlanstown on his way from Cavan to Tara. His monks were thirsty and local people refused to give them a drink, so Patrick struck the ground with his crozier and the well sprang up. Some stones at the bottom of the well are red in colour, and local people told us that this is said to be the stain from the saint's blood.

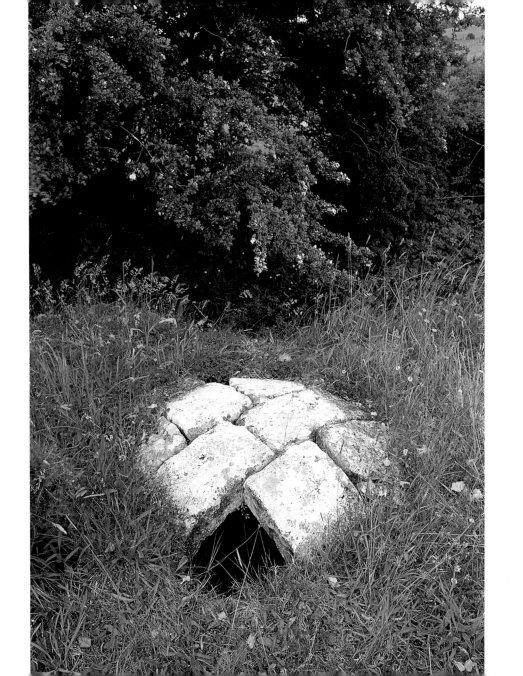

Saint Gobnait's well

Townland
Glebe

Parish
Ballyvourney

County
Cork

On the Macroom-to-Killarney road, at the foot of the Derrynasaggart mountains, lies the village of Ballyvourney. A left turn in the village leads up to Saint Gobnait's well, where local people gather on the 11th of February, the saint's feast day. There are two wells at Ballyvourney, and the rosary is said at the upper well before people disperse to perform the rounds, stopping at some unusual penitential stations along the way. One of these is a sheila-na-gig, built into the southern wall of Saint Gobnait's Abbey; another is Saint Gobnait's Bowl, a cannonball lodged in the abbey's western wall. It is said that Gobnait destroyed a nearby castle, owned by a pagan chief, with one strike of this ball. She also confronted a cattle-thief in the area, warning him off by commanding bees from her hive to swarm him. Gobnait saved the district from the plague by blessing a field, still known as *Goirtín na Plá*, meaning 'Field of the Plague', across which pestilence could not pass. Gobnait's importance in the area is such that her feast day has been a holy day here for many centuries.

Saint Fechin's well

Townland
Gooreen

Parish
Omey Island

County
Galway

Exposed to the extremes of the Atlantic on the western shores of Omey Island, this well has survived here since the beginning of the seventh century. It is said the well sprang up when Saint Fechin came to the island to convert the people to Christianity. Initially, the islanders were hostile to the saint and tried to stop him building his church by throwing the tools into the sea every night. However, each morning the tools had returned to their proper places, as if no one had touched them. The ruins of this church can still be seen a few hundred yards from the well. According to legend, a foreign ship landed on the island and Saint Fechin tried to convert its pagan captain. The captain threw his ring into the sea and declared that if he found the ring beside the well he would believe. They walked to the well and found the ring there, so the captain converted.

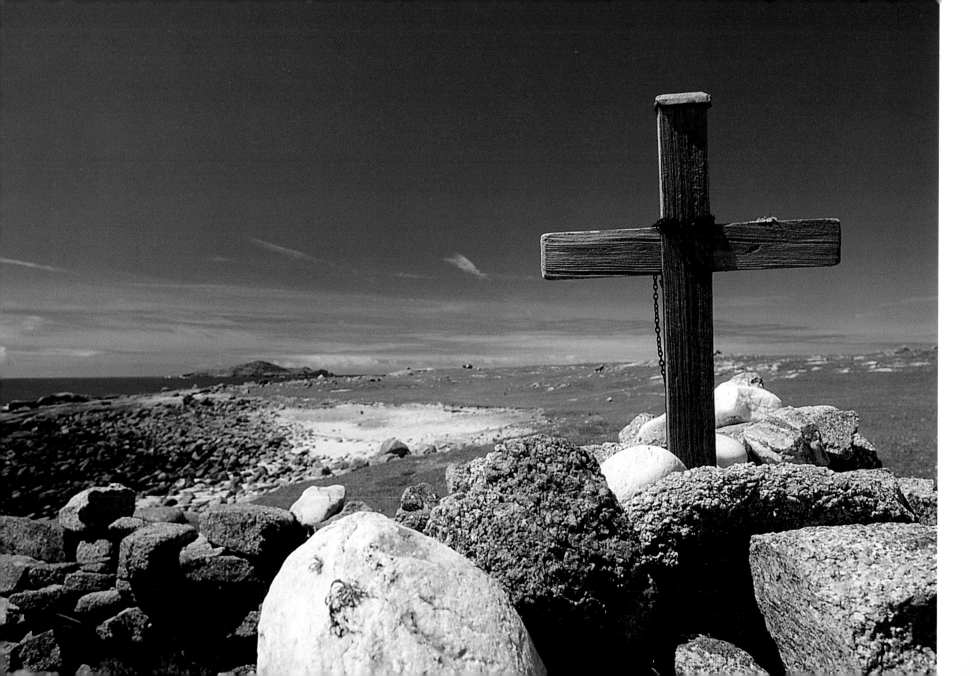

Perry's well

This well has seen much modernisation since 1912, when Reverend Samuel Hemphill, canon of Saint Patrick's cathedral in Dublin, visited it. Hemphill, remembering the well from his childhood days, describes pilgrims climbing onto the vaulted roof of the sixteenth-century well-house to sit on a special seat there. About thirty years ago a branch from a chestnut tree beside the well fell on the roof, destroying it. A local farmer rebuilt the vault and pebble-dashed the exterior rough limestone walls. The interior remains largely unchanged. Local tradition records that people used to sit on the stone ledges, bathing their feet in the cold stream that flows along the floor. The well is not dedicated to any saint; it gets its name from the Perry family, who lived near the well for many generations. A small iron figure of a swordsman, which used to lean up against the exterior gable of the building, disappeared about ten years ago. A stone-carved effigy of the Pietá was lying in the tangled grass nearby when we visited. Although the place seems very neglected, we were told that people still occasionally visit.

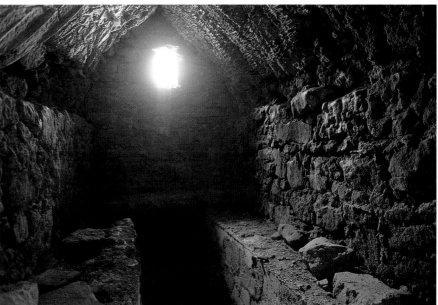

Saint Hugh's well

Townland
Rahugh

Parish
Rahugh

County
Westmeath

Saint Hugh's well is hidden in a dip of a large open field close to the ruins of his church. The saint, who was a sixth-century bishop known as Aedh or Aodh Mac Bric, performed many miracles during his life. They included healing, transportation through the air, turning water into wine and resuscitating three people whose throats had been cut by robbers. Saint Brigid is reputed to have gone to him to remedy a chronic headache. A flat stone near the well has a number of marks said to represent the saint's forehead, elbows and knees. This stone is still used for curing headaches. In former times people tied offerings and rags to a hawthorn bush that stood over the well. It is said the landowner, wanting to do away with the offerings, decided he would set fire to the tree. He seated himself in an armchair to watch it burn but died suddenly as soon as the tree caught fire. The pattern, which was formerly held on the 1st of November, is thought to have ceased almost three hundred years ago.

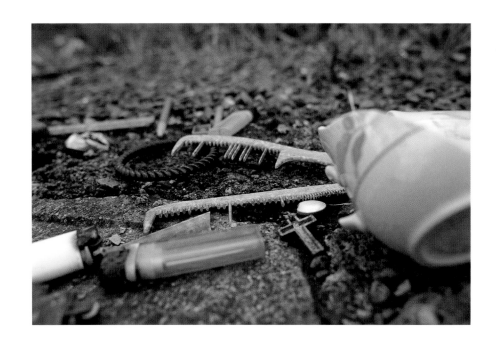

Saint Moling's well

Townland
St Mullins

Parish
St Mullins

County
Carlow

A pattern takes place here on the last Sunday before the 25th of July, and huge crowds of people still attend. We watched as a marching band led the procession from the well to the graveyard, where the rosary was said. Afterwards people made their way back to the well, where they drank the water and filled bottles to take home with them. After a visit to the well some people sat on the grass eating burgers and sweets being sold from temporary stalls nearby. Others enjoyed a pint outside the local pub and a band played from the trailer of an articulated lorry. The well consists of a large pool, which is said to have seven springs in it. Water flows from the pool through two holes cut into large flagstones that form the gable wall of the well-house. A tradition still practised today involves dousing a child's head three times in the flow of water, in order to protect him or her from the flu and other head ailments. Visiting the well three times is said to cure warts. In 1350 huge numbers of people from all over Ireland came here to do penance, in the hope it would save them from the terrors of the Plague, which was sweeping the country at the time.

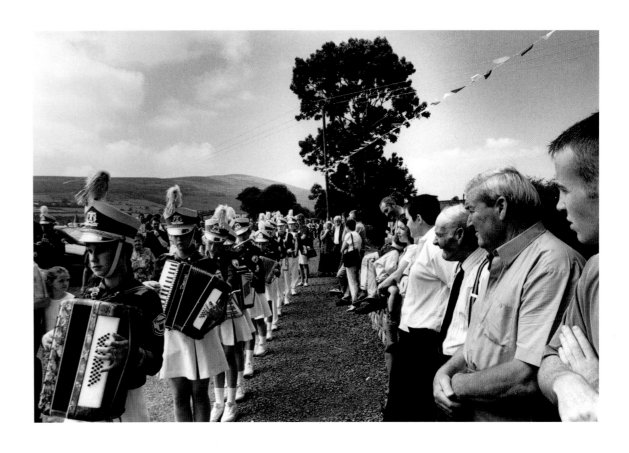

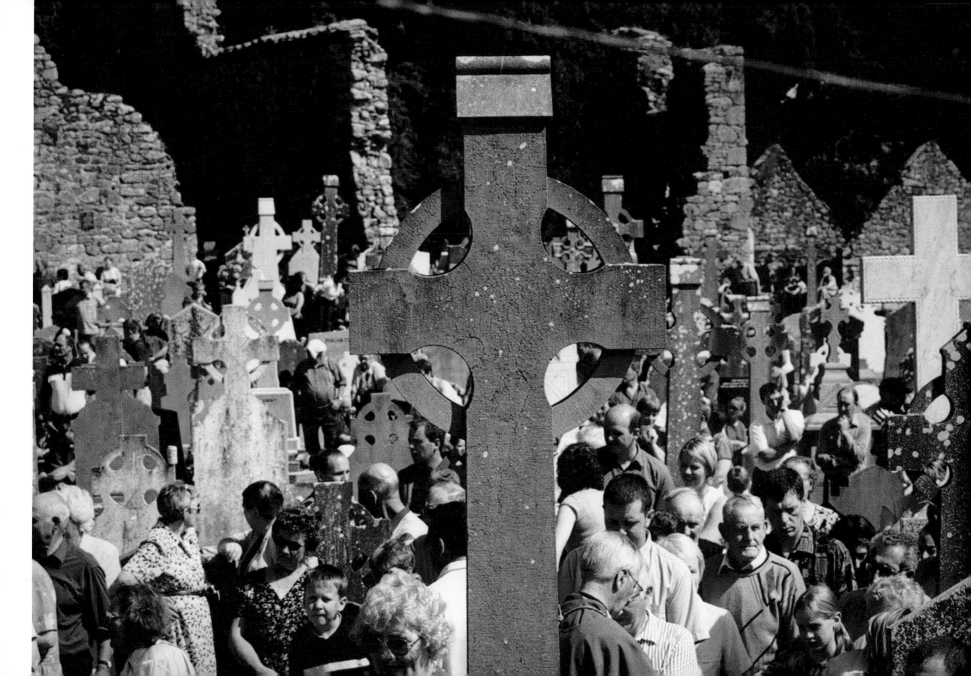

Well of the Holy Women *Tobar na mBan Naomh*

Townland
Rinnakill

Parish
Glencolmcille

County
Donegal

The Holy Women of this well were three sisters, locally known as Ciall, Tuigse and Náire (Sense, Understanding and Modesty). The sisters lived near the well, and when they became nuns they blessed it. As fishermen sailed out of Teelin Bay, it was traditional for them to lower their sails and take off their caps as a salute to the well, asking the Holy Women to bless their journey. Another well nearby, called the Well of the Fair Winds, was also thought to influence the weather. If it was too stormy for boats to get home, this well was 'cleared out' to procure more favourable winds. However, there was a danger that a family member of the person who cleared it out might die. The annual pilgrimage takes place on the 23rd of June, Saint John's Eve, also known as Bonfire Night. Three rounded stones at the well are used for healing; each stone is passed around the body three times and then touched to the lips.

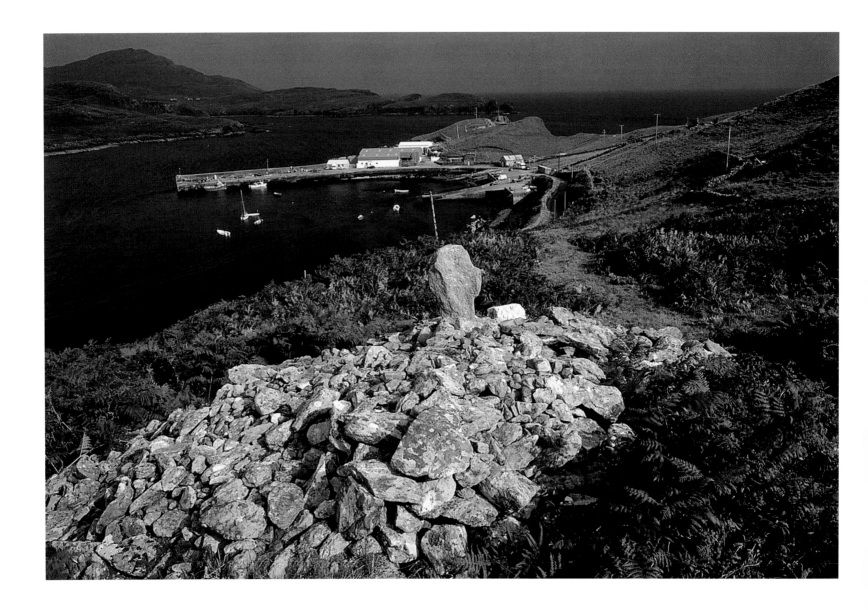

Saint Anne's well

Townland
Killanne

Parish
Killanne

County
Wexford

This well is believed to have been originally situated about a mile from its present location. Local folklore tells us that in the early 1600s the owner of the land fenced it off to discourage pilgrims from trespassing. The well (in disgust?) dried up and miraculously relocated itself to its present site behind the old graveyard in Killanne. I remember the bustle and excitement of pattern day here from my childhood. People from all over the parish gathered at the graveyard of our otherwise sleepy village. Hawkers came out from town, setting up sweet-stalls on rickety prams. Dressed in our summer Sunday best, we dutifully said our rosary and then followed the procession down to the well to drink the blessed water. Once our religious obligations had been fulfilled, we hurried off to play with the other children late into the evening. The pattern continues to take place on the 24th of July every year.

Well of the Holy Cross *Tobar na Croiche Naoimhe*

Townland
Gleninagh

Parish
Gleninagh

County
Clare

This fifteenth-century well-house stands north of Ballyvaughan and close to the rocky seashore. The pointed-arch doorway is just large enough to get through. When one is crouched in the doorway with all the light blocked out, it takes a few seconds to adjust to the darkness. Immediately inside, on the right, is a stone shelf where a few humble offerings were left: a shell, a cloth tied with a safety pin and a small glass with freshly cut ivy in it. In former times this well was visited principally for curing sore eyes, and the tree over the well was festooned with votive rags.

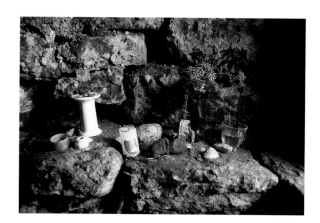

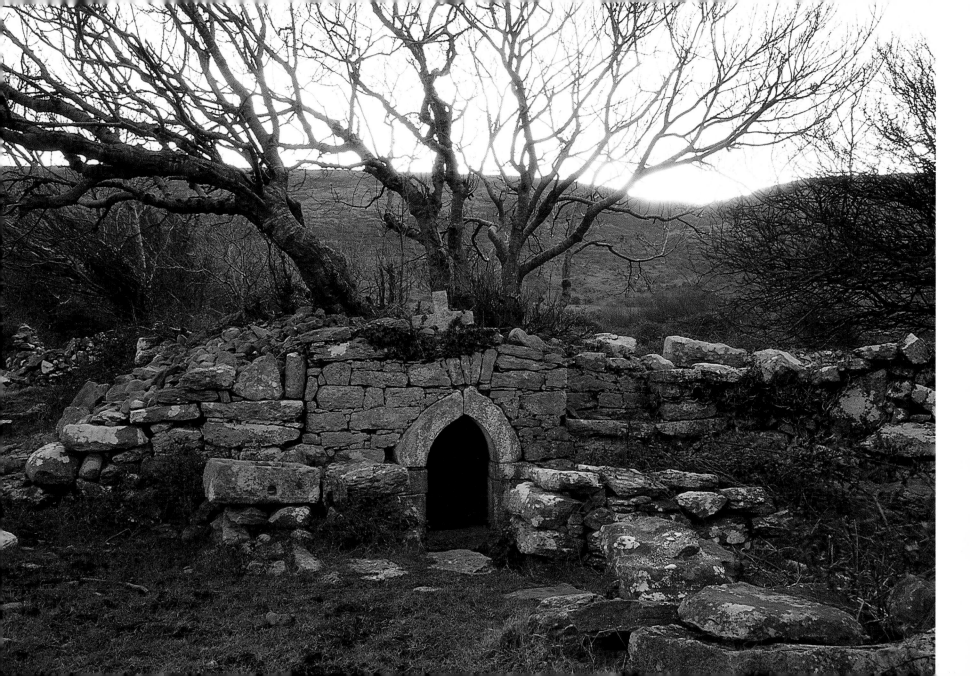

Saint Catherine's well

Townland
Glebe

Parish
Killybegs Upper

County
Donegal

This well is dedicated to Saint Catherine of Alexandria, patroness of women students, philosophers, wheelwrights and millers. Local tradition has it that three Irish priests were ordained in Rome around the time when Catherine was being canonised. On the return journey their ship was caught in fierce storms off the coast of Donegal. The priests prayed to Saint Catherine for her help and intervention. On landing safely, they happened upon the well and dedicated it to the saint in thanksgiving. The pattern day on the 25th of November is the saint's feast day, and in earlier times it attracted large crowds. According to folklore, in 1850 a Protestant rector filled in the well with earth. The next day a spring burst up in his sitting-room. His wife persuaded him to reopen the well.

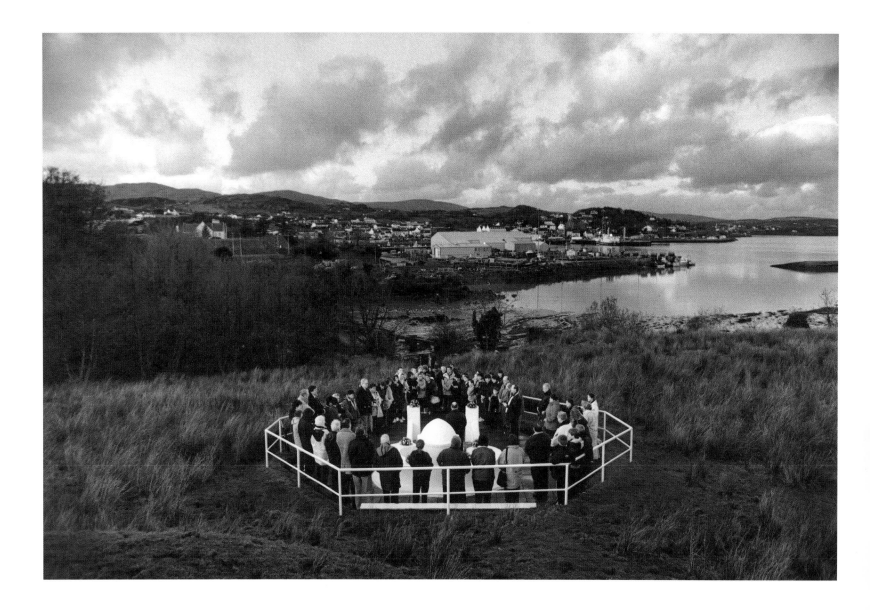

Saint Colman's well

Townland
Corker

Parish
Kiltartan

County
Galway

Saint Colman was believed to be an heir to the throne of Connacht, and rivals for the kingship hunted Colman's mother, Ríonach, while she was still pregnant. Tying a stone around her neck, they threw her into the deepest part of the Kiltartan river. She miraculously escaped and travelled to Corker where, under an ash tree at the present site of the well, she gave birth. Soon afterwards two pilgrim monks, one blind and the other lame, passed by. Ríonach asked the monks to baptise her son, but there was no water nearby to do so. The blind monk pulled up a tuft of rushes and the well sprang up, splashing the monk's eyes and restoring his sight. The lame monk washed his leg in the water and was cured. Colman was baptised with this water. The well is still visited for eye cures today. The little octagonal oratory and statue of the saint were erected over the well in 1912. A large dead ash tree stands over the building; this tree is said to protect people in the area from lightning. The annual pattern was revived in 1947 and takes place on the 29th of October every year.

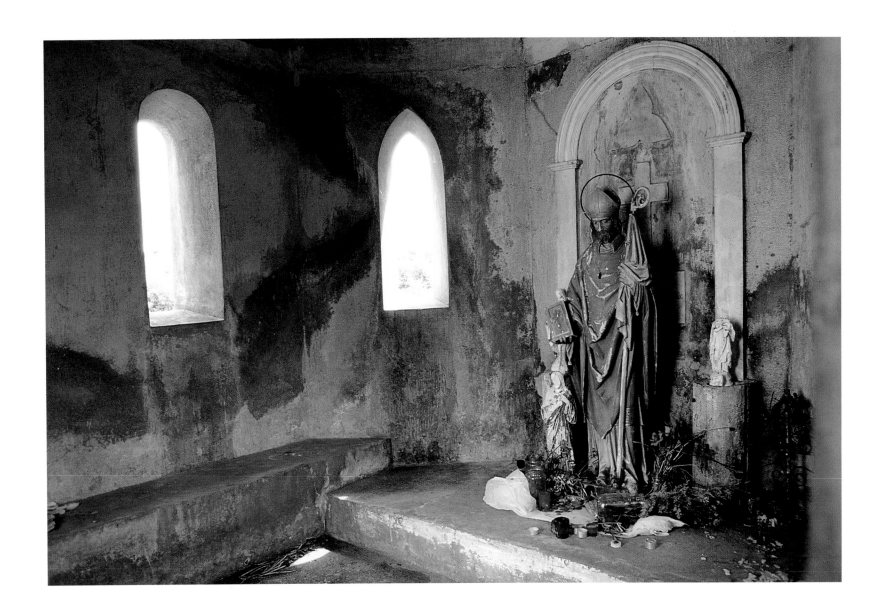

Blessed well

Townland
Ballinacoola

Parish
Templeshanbo

County
Wexford

A series of long, winding grassy laneways lead off the main road down to a small stream. The well is reached by traversing a muddy patch of ground and then crossing a rickety footbridge. In 1896, Father O'Neill, who was originally from the locality, sent money home from America for this well to be renovated. At the time the cattle in the area were dying from 'blackleg'; once the well was cleared out, the cattle were cured. The Virgin Mary is said to have appeared here to a local girl in 1984. A number of apparitions of the Virgin Mary were reported around Ireland in that year, the most famous of them being at a grotto in Ballinspittle, County Cork.

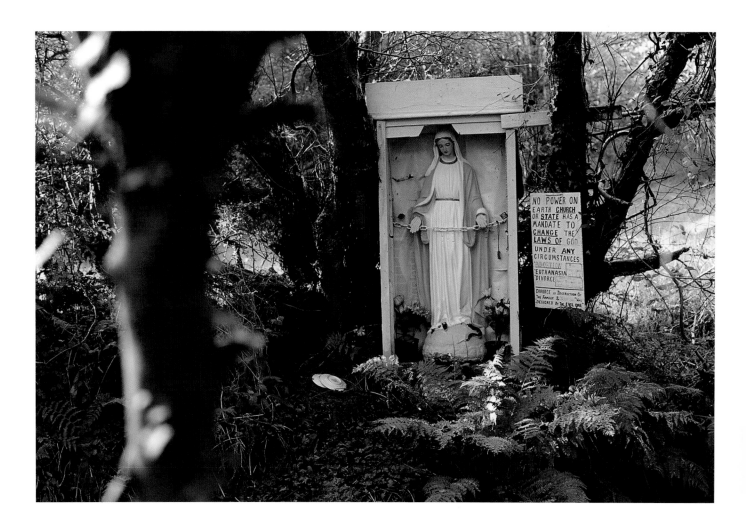

Tobermurry/Mary's well

Townland
Rosserk

Parish
Ballysakeery

County
Mayo

Tobermurry lies southeast of Rosserk Abbey, about three miles north of Ballina near the mouth of the river Moy. Access to the well is difficult; a waterlogged field lay between the well and us. There was no obvious path and no easy way around the expanse of mud. A sign on the gable wall of a cowshed halfway down the field assured us we were at least going in the right direction. The well itself is housed in a miniature stone chapel with one tiny door just big enough to crawl through and a gnarled hawthorn growing from the vaulted stone roof. Inside, fine silt covered the floor; stones, statues and coins were all completely submerged in crystal-clear water. There are two conflicting inscriptions on the stone chapel relating to when it was built. One in English tells us it was built by John Lynott of Rosserk in 1798. The other inscription, in Latin, implies that it was built on the 30th of August 1684.

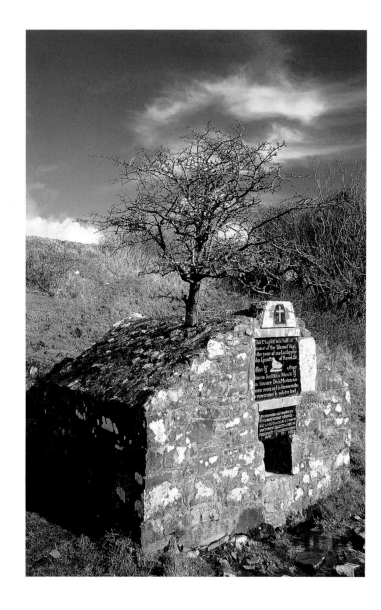

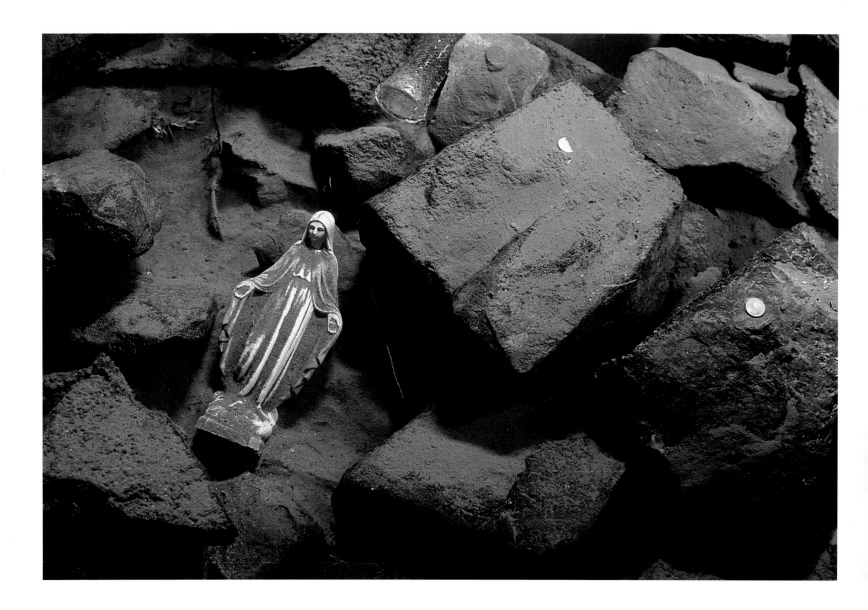

Tobernalt *Tobar an Ailt*

Townland
Aghamore Near

Parish
St John's

County
Sligo

Tobernalt, or *Tobar an Ailt* in Irish, meaning 'Well at the Cliff', is not dedicated to any saint, although Saint Patrick is said to have visited the district. A stone on the Mass Rock has a number of small depressions in it, thought to be the imprints of Saint Patrick's fingers. Traditionally, a pilgrim who places his fingers in these holes will have his prayers answered. Other stones at the well are said to cure backache and headache. The pattern day, still celebrated on the last Sunday in July, is known as Garland Sunday, commemorating the festival of Lughnasa, or Lammastide, one of the four quarterday festivals in the Celtic calendar. In Penal times masses were said at this secluded spot, children were baptised and couples married. The well continues to be exceptionally popular, attracting visitors all year round and large crowds on Garland Sunday.

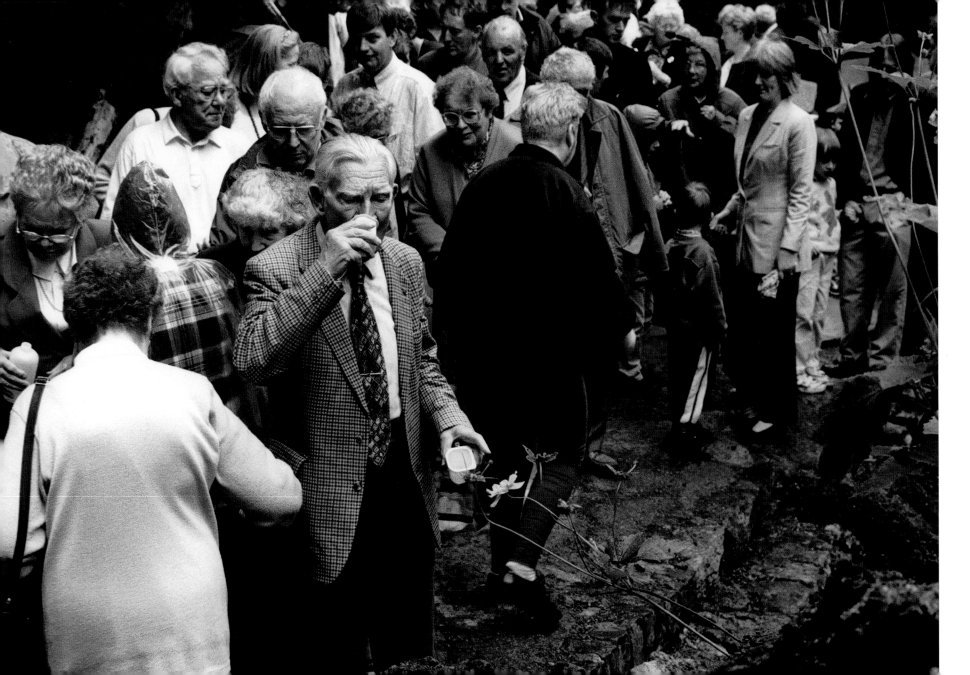

Saint Patrick's chair and well

Townland
Altadaven

Parish
Clogher

County
Tyrone

A narrow track twists its way through the tall pines of Altadaven woods and up to the rocky outcrop where Saint Patrick's chair and well are found. In the wet, wintry afternoon light the forest took on an otherworldly atmosphere. It is said that Saint Patrick preached from the stone chair before baptising people in the well. The well is a natural hollow (in this case an almost perfect circle) in the rock known as a *bullán*. Legend has it that all the devils and serpents of Ireland dwelt in this spot before Saint Patrick banished them into the local lake, Lough Beag. Its name, Ailt a' Deamhain, means Cliff of the Demon. An annual gathering, locally known as 'The Big Sunday of the Heather' or 'Blaeberry Sunday', used to take place here on the Sunday following the 26th of July, celebrating the ancient harvest festival, Lughnasa. On that day people climbed the rock and sat in the chair to make a wish. They then visited the well, leaving a pin or a penny behind as an offering. Afterwards people played games and picked blueberries. It is thought the tradition ceased sometime in the middle of the twentieth century.

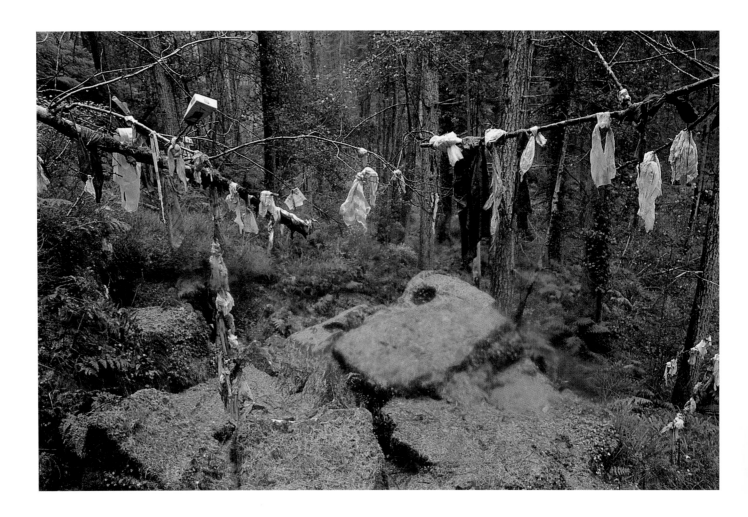

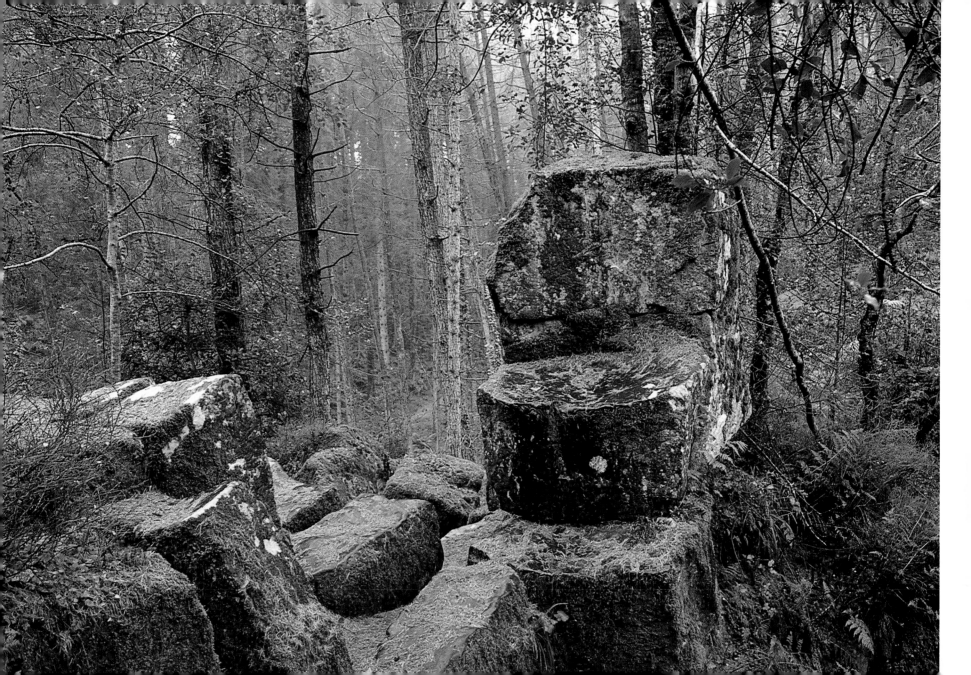

Map of wells

01 Saint Colman's well, Cranfield, Cranfield, Antrim

02 Saint Michael's well, Tinnahinch, St Mullins, Carlow

03 Saint Molings well, St Mullins, St Mullins, Carlow

04 Saint Patrick's well, Patrickswell, Rathvilly, Carlow

05 Poll Insheen wells, Gleninsheen, Rathborney, Clare

06 Saint Brigid's well, Ballysteen, Kilmacrehy, Clare

07 Saint Flannan's well, Drimanure, Inagh, Clare

08 Saint Joseph's well, Dulick, Templemaley, Clare

09 Saint Caoidhe's well, *Tobar Caoidhe*, Foohagh, Kilfeeragh, Clare

10 Well of the Holy Cross, *Tobar na Croiche Naoimhe*,
Gleninagh, Gleninagh, Clare

11 Saint Gobnait's well, Glebe, Ballyvourney, Cork

12 Skour well, Highfield, Creagh, Cork

13 Saint Catherine's well, Glebe, Killybegs Upper, Donegal

14 Saint Ciarán's well, Bavan, Kilcar, Donegal

15 Saint Columcille's well, Beefan, Glencolumcille, Donegal

16 Angels well, *Tobar na nAingeal*, Bindoo, Kilteevoge, Donegal

17 Well of the Holy Women, *Tobar na mBan Naomh*, Rinnakill,
Glencolmcille, Donegal

18 Saint Ceannanach's well, Clooncree, Ballynakill, Galway

19 Saint Colman's well, Corker, Kiltartan, Galway

20 Saint Fechin's well, Gooreen, Omey Island, Galway

21 Saint Kieran's well, *Tobar Chiaráin*, Kilkieran, Moyrus, Galway

22 Saint Fechin's well, *Tobar Feichín*, Cammanagh, Ross, Galway

23 Mary's well, Saint Fechin's well, *Tobar Mhuire, Tobar Feichín*,
Dooghta, Cong, Galway

24 Saint Patrick's well, *Tobar Phádraig*, Teernakill South, Ross, Galway

25 Our Lady's well, *Tobar Mhuire*, Kinard, Kinard, Kerry

26 Wether's well, *Tobar na Molt*, Tubbrid More, Ardfert, Kerry

27 Saint Brigid's well, Riverstown, Ballybracken, Kildare

28 Saint Moling's well, Mullennakill, Jerpoint West, Kilkenny

29 Mary's well, *Tobar Mhuire*, Killarga, Killarga, Leitrim

30 Saint Patrick's well, Cartron, Granard, Longford

31 The Blessed well, Kilgeever, Kilgeever, Mayo

32 Saint Colman's well, *Tobar Cholmáin*, Slievemore, Achill, Mayo

33 Tobermurry/Mary's well, Rosserk, Ballysakeery, Mayo

34 Saint Kieran's well, Castlekeeran, Castlekeeran, Meath

35 Saint Patrick's well, Carlanstown, Kilbeg, Meath

36 Saint Manchan's well, Lemanaghan, Lemanaghan, Offaly

37 Tobar Ogulla, Ogulla, Ogulla, Roscommon

38 Saint James's well, Carrownyclowan, Shancough, Sligo

39 Saint Patrick's well, Dromard, Dromard, Sligo

40 Tobernalt, *Tobar an Ailt*, Aghamore Near, St John's, Sligo

41 Perry's well, Kilboy, Kilmore, Tipperary

42 Saint Patrick's chair and well, Altadaven, Clogher, Tyrone

43 Saint Hugh's well, Rahugh, Rahugh, Westmeath

44 Blessed well, Ballinacoola, Templeshanbo, Wexford

45 Lady's well, Lady's Island, Ladyisland, Wexford

46 Saint Anne's well, Killanne, Killanne, Wexford

47 Saint David's well, Ballynaslaney, Ballynaslaney, Wexford

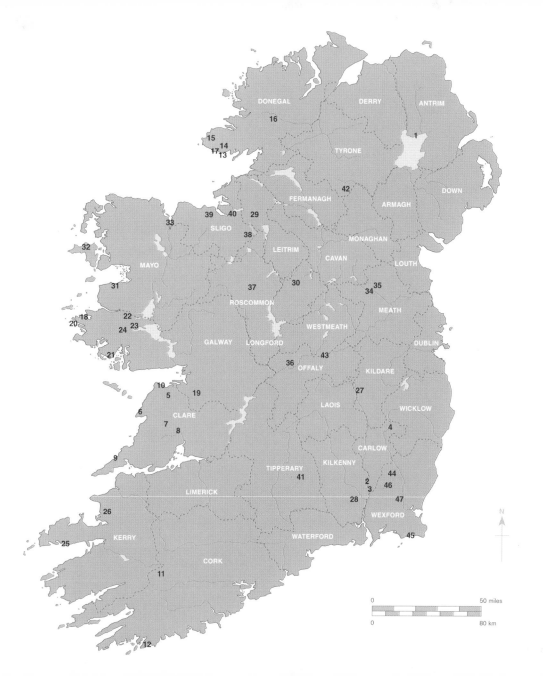

DONEGAL

16

15 14
17 13

DERRY

ANTRIM

TYRONE

1

DOWN

FERMANAGH

42

ARMAGH

33

39 40 29

SLIGO

38

MONAGHAN

LOUTH

32

LEITRIM

CAVAN

MAYO

31

37

30

34 35

ROSCOMMON

MEATH

18
22
20 24 23

WESTMEATH

21

GALWAY

LONGFORD

DUBLIN

36

43

OFFALY

KILDARE

10
5

19

27

LAOIS

WICKLOW

6

CLARE

7
8

4

9

CARLOW

TIPPERARY

KILKENNY

44

41

2

3

46

28

47

26

LIMERICK

WEXFORD

25

KERRY

WATERFORD

45

11

CORK

12

N

0 50 miles

0 80 km

© Matthew Stout

Glossary

Bullán *an artificial hollow in a stone*

Clootie tree *a tree or bush with offerings (clooties) tied to its branches, also known as a 'rag tree'*

Leac *a flagstone*

May Eve *the eve of the 1st of May, Bealtaine, the Mayday festival celebrating the start of the summer half of the year*

Michaelmas *Saint Michael the Archangel's feast day, the 29th of September*

Novena *a devotion consisting of prayers performed on nine consecutive days*

Pattern Day *a special day of pilgrimage to the well usually held on the saint's feast day (Patron day) or connected to a festival of Celtic origin such as Lughnasa*

Penal Laws *laws enacted in 18th-century Ireland restricting the freedom of Catholics and the Catholic Church*

Prayer round or 'round' *a pilgrimage made walking clockwise around the well or well enclosure, often on a rounds path, reciting certain prayers*

Rosary *a series of 5 decades of Hail Marys, beginning with an Our Father and ending with a Gloria*

Sheila-na-gig *effigy of supernatural female displaying her genitalia*

Stations *stages along the pilgrimage or rounds path where people pray or perform penitential exercises, usually marked by stones, crosses or monastic remains*

Tobar *a well*

Turas *prayer round or pilgrimage*

Bibliography

Saint Colman's well, Cranfield, Cranfield, Antrim

Bigger, Francis Joseph 'Cranfield Church and Holy Well' (1911)

Foster, Jeanne Cooper *Ulster Folklore* (1951) pp. 114–5

Saint Michael's well, Tinnahinch, St Mullins, Carlow

Local information

Saint Moling's well, St Mullins, St Mullins, Carlow

Ffrench, Rev. J.F.M. 'St. Mullins Co. Carlow' JRSAI ser. 5, vol. 22 (1892) pp. 377–88

Local information

Saint Patrick's well, Patrickswell, Rathvilly, Carlow

IFCS vol. 468, p. 14

O'Toole, Edward 'The Holy Wells of County Carlow' *Bealoideas* vol. 4, no. 1–2, Dec. (1933) p. 4

Poll Insheen wells, Gleninsheen, Rathborney, Clare

Doolin, Lelia 'Lore and Cures and Blessed Wells' from The Book of the Burren (1991)

Saint Brigid's well, Ballysteen, Kilmacrehy, Clare

MacNeill, Máire *The Festival of Lughnasa* (1962) p. 276

IFCM vol. 466, pp. 62–4

Local information

Saint Flannan's well, Drimanure, Inagh, Clare

IFCS vol. 611, p. 112

Local information

Saint Joseph's well, Dulick, Templemaley, Clare

Lenihan, Edmund 'The Holy Wells of Doora-Barefield parish' *The Other Clare* vol. 18 (1994) p. 43

Westropp, T.J. 'Folklore Survey of County Clare' *Folklore* vol. 22, 1 (1912) p. 213

IFCS vol. 594, pp. 114 and 120

Curry, Eugene and John O'Donovan 'O.S. Letters' vol. 1 (1839) p. 16

Tobar Caoidhe, Foohagh, Kilfeeragh, Clare

IFCM vol. 466, p. 127

Curry, Eugene 'O.S. Letters' vol. 1 (1839) p. 354

Tobar na Croiche Naoimhe, Gleninagh, Gleninagh, Clare

O'Donovan, John 'O.S. Letters' vol. 1 (1839) p. 84

Saint Gobnait's well, Glebe, Ballyvourney, Cork

O'Hanlon *Lives of the Irish Saints* (1875) vol. 2, pp. 462–70

Guest, Edith M. 'Ballyvourney and it's Sheela-na-Gig' *Folklore* vol. 48 (1937) pp. 374–84

IFCM vol. 466, p. 166

Skour well, Highfield, Creagh, Cork

IFCS vol. 297, pp. 141–2

JCHAS vol. 65 no. 202, July–December (1960)

Local information

Saint Catherine's well, Glebe, Killybegs Upper, Donegal

Local information

Saint Ciarán's well, Bavan, Kilcar, Donegal

O'Grady, Standish H. 'Saint Kieran of Saighir' *Silva Gadelica* (1892) p. 2

O'Muirgheasa, Énrí 'The Holy Wells of Donegal' *Bealoideas* vol. 4 (1936) pp. 146–7

O'Hanlon *Lives of the Irish Saints* (1875) vol. 3, pp. 115–48

Saint Columcille's well, Beefan, Glencolumcille, Donegal

O'Muirgheasa, Énrí 'The Holy Wells of Donegal' *Bealoideas* vol. 4 (1936) pp. 150, 162

Local information

Tobar na nAingeal, Bindoo, Kilteevoge, Donegal

IFCS vol. 1093, pp. 65, 339

Ua Maolain, S. 'Tobar na n-Aingeal' JDHS vol. 1, no. 3 (1949) pp. 206–7

Local information

Tobar na mBan Naomh, Rinnakill, Glencolmcille, Donegal

O'Muirgheasa, Énrí 'The Holy Wells of Donegal' *Bealoideas* vol. 4 (1936) pp. 162, 150

Taylor, Laurence J. *Occasions of Faith* (1984) pp. 35–8

Saint Ceannanach's well, Clooncree, Ballynakill, Galway

IFCS vol. 6, p. 116

Killanin and Duignan *Shell Guide to Ireland* (1967) p. 164

O'Donovan, John 'O.S. Letters Galway' vol. 3 (1839) pp. 13, 62, 215

Saint Colman's well, Corker, Kiltartan, Galway

Long, Brendan 'Saint Colman's Well' *Guaire Magazine*

Noone, Bob 'Cures at St. Colman's well' *Guaire Magazine*

Local information

Saint Fechin's well, Gooreen, Omey Island, Galway

IFCM vol. 467, pp. 88–91

Tobar Chiaráin, Kilkieran, Moyrus, Galway

Local information

Tobar Feichín, Cammanagh, Ross, Galway

O'Hanlon *Lives of the Saints* (1875) vol. 1, pp. 356–82

Tobar Mhuire, Tobar Feichín, Dooghta, Cong, Galway

Otway, Ceasar *Tour in Connaught* (1839) pp. 246–51

O'Flaherty, Roderic *A chorographical description of West or H-IAR Connaught* (1684) p. 121

Tobar Phádraig, Teernakill South, Ross, Galway

Cosgrave, H.A. 'Saint Patrick's Well and Bed' JRSAI (1913) vol. 13

Inglis, Henry D. *Ireland in 1834* vol. 2, pp. 46–53

Tobar Mhuire, Kinard, Kinard, Kerry

O'Danachair, Caoimhín 'The Holy Wells of Corkaguiney' JRSAI, vol. 90 (1960) p. 75

Tobar na Molt, Tubbrid More, Ardfert, Kerry

IFCM vol. 1823, p. 3

Fitzgerald, Lord Walter MDI vol. 8 (1912) p. 570

O'Danachair, Caoimhín 'The Holy Wells of North Kerry' JRSAI vol. 88 (1958) pp. 156–7

Míceal ua Riogbardain and Tomás ua Ciarrbáic *Twixt Skellig and Scattery* (1932) pp. 37–40

Toal, Caroline *North Kerry Archaeological Survey* (1995) p. 232

Talbot-Crosbie, Bligh, 'Tobar na Molt' *Kerry Archaeological Magazine* vol. 1 (1908–12) pp. 421–38

Saint Brigid's well, Riverstown, Ballybracken, Kildare
IFCS vol. 780, p. 169
Jackson, Patricia JKAS vol. 26 (1979–80) p. 158

Saint Moling's well, Mullennakill, Jerpoint West, Kilkenny
Murphy, Canon William 'The Pattern of Mullinakill' *Old Kilkenny Review*
no. 22 (1970) pp. 42–4
Local information

Tobar Mhuire, Killarga, Killarga, Leitrim
Local information

Saint Patrick's well, Cartron, Granard, Longford
MacNerney, James P. 'From the Well of Saint Patrick, Dromard Parish' (2000)
Bennett J. 'Sliabh Chairbre' *Teathbha – Journal of the Longford Historical
Society* (1969)
Devaney, Fr Owen *History of Killoe Parish* (1981) p. 94
'O.S. Names Books Longford' no. 91 (1832) p. 399
Local information

The Blessed Well, Kilgeever, Kilgeever, Mayo
IFCS vol. 86, p. 97
Higgons, J. and M. Gibbons 'Early Christian Monuments at Kilgeever'
Cathair na Mart no. 13 (1993) pp. 36–8

Tobar Cholmáin, Slievemore, Achill, Mayo
IFCS vol. 86, p. 256
Howard, John E. *The Island of Saints* (1855) p. 177
McDonald, Theresa *Achill 5000 BC to 1900 AD* (1992) pp. 103, 143

Tobermurry/Mary's well, Rosserk, Ballysakeery, Mayo
O'Hara, Rev. 'Rosserk and Moyne' JRSAI vol. 28 (1898) pp. 258–60
IFCS vol. 145, p. 142
'O.S. Name Books Mayo' no. 98, p. 122

Saint Kieran's well, Castlekeeran, Castlekeeran, Meath
Wilde, Sir William *Beauties and Antiquities of the Boyne* (1849) p. 141–3
Wood–Martin, W.G. *Traces of the Elder Faiths of Ireland* vol. 2 (1902) pp.
109–11
IFCM vol. 468, p. 250
Local information

Saint Patrick's well, Carlanstown, Kilbeg, Meath
IFCS vol. 708, pp. 16, 54, 203–9 and vol. 709, pp.21, 42, 86, 100, 120
Local information

Saint Manchan's well, Lemanaghan, Lemanaghan, Offaly
IFCS vol. 811, pp. 86, 103
O'Hanlon *Lives of the Irish Saints* vol.1, p. 410
MacConnell, Séan 'Irish Times Midlands Report' March 4 1999
Local information

Tobar Ogulla, Ogulla, Ogulla, Roscommon
Gormely, Mary *Tulsk Parish History and Folklore* (1989) pp. 63–7
Betham, William *Irish Antiquarian Researchs* (1827) vol. 2, pp. 367–70
Swift, Edmund L. *The Life of Saint Patrick* (1809) pp. 80–1

Saint James's well, Carrownyclowan, Shancough, Sligo
O'Donovan, John 'O.S Letters Sligo' (1836) p. 99
MacNeill, Máire *The Festival of Lugnasa* (1962) p. 608

Saint Patrick's well, Dromard, Dromard, Sligo
IFCS vol. 169, pp. 21, 25–7, 398
Local information

Tobar an Ailt, Aghamore Near, St John's, Sligo
IFCM vol. 467, p. 190
Boylan Eamonn *Tobernalt Holy Well: History and Heritage* (1999)
MacNeill, Máire *The Festival of Lughnasa* (1962) p. 607
Wood-Martin, W.G. *Traces of the Elder Faiths of Ireland* vol. 2 (1902) p. 101

Perry's well, Kilboy, Kilmore, Tipperary
OPW Sites and Monuments Archaeological Survey, Tipperary
Hemphill, Rev. Samuel 'The Holy Well at Kilboy' JRSAI vol. 42 (1912) pp. 325–30
Local information

Saint Patrick's chair and well, Altadaven, Clogher, Tyrone
MacNeill, Máire *The Festival of Lugnasa* (1962) pp. 516, 517, 153, 155

Saint Hugh's well, Rahugh, Rahugh, Westmeath
IFCS vol. 732, p. 279

Blessed well, Ballinacoola, Templeshanbo, Wexford
IFCS vol. 892, p. 247
Local information

Lady's well, Lady's Island, Ladyisland, Wexford
Hore, P.H. 'The Barony Forth' December (1925) *The Past* no.3, pp. 20–3
MacLeigim, 'A Survey of the Ancient Things in Lady's Island District'
The Past (1920) vol. 1, pp. 133–7
'Irish Saints, Shrines and Holy Wells' Mac Publications, Dublin pp. 56–8

Saint Anne's well, Killanne, Killanne, Wexford
O'Donovan, John 'O.S. Letters Wexford' (1840) vol. 2, pp. 102–3
Local information

Saint David's well, Ballynaslaney, Ballynaslaney, Wexford
O'Donovan, John 'O.S. Letters Wexford' (1840) vol. 2, p. 96
Local information

IFCM Irish Folklore Collection main vols.
466–8, questionnaire on holy wells

IFCS Irish Folklore Collection Schools